IMAGES
of America

LIGHTHOUSES OF BAR HARBOR AND THE ACADIA REGION

On the cover: Linwood Gammon, the lighthouse keeper at Egg Rock Lighthouse, returns with provisions to the lighthouse in 1946. The lighthouse is located at the entrance to Frenchman's Bay near Winter Harbor. (Courtesy U.S. Coast Guard.)

IMAGES
of America

LIGHTHOUSES OF BAR HARBOR AND THE ACADIA REGION

Timothy E. Harrison

ARCADIA
PUBLISHING

Published by Arcadia Publishing
Charleston SC, Chicago IL, Portsmouth NH, San Francisco CA

Printed in the United States of America

Library of Congress Control Number: 2008933031

For all general information contact Arcadia Publishing at:
Telephone 843-853-2070
Fax 843-853-0044
E-mail sales@arcadiapublishing.com
For customer service and orders:
Toll-Free 1-888-313-2665

Visit us on the Internet at www.arcadiapublishing.com

*To the memory of the employees of the United States Lighthouse Service
and the United States Coast Guard and their families, who served so
selflessly and faithfully in many different capacities that gave our nation
the best system of aids to navigation the world has ever known. Also,
to the memory of the late Ken Black, founder of the Maine Lighthouse
Museum, in Rockland, who was known by many as "Mr. Lighthouse."
He was my guiding light that led me to saving and recording lighthouse
history. May the legacy they gave us shine on forever.*

CONTENTS

ACKNOWLEDGMENTS

Compiling information and photographs that chronicle the history of the people who developed, built, managed, serviced, maintained, and lived at the lighthouses of the Bar Harbor and Acadia region was no small task. The photographs and information contained in the pages of this book have been collected over a period of years from many different individuals who were willing to share their photographs and recorded memories and stories with me so that this vital part of America's maritime history could be saved for future generations. There are too many names to mention, but they know who they are, and I thank them from the bottom of my heart.

INTRODUCTION

Lighthouses were built for one purpose only—to save lives. Because the early people of the United States understood the need for lighthouses, the colonies built a number of early lighthouses, which in turn helped commerce and people to safely arrive in our ports, which in turn led to the rapid growth and development of the colonies.

Realizing the importance of lighthouses, on August 7, 1789, the First Congress of the United States of America federalized all lighthouses that had been built by the colonies. From 1789 to 1939, our nation's lighthouses operated under various government agencies and had several names, such as the United States Lighthouse Establishment (USLHE), the Lighthouse Board, the Bureau of Lighthouses, and the United States Lighthouse Service (USLHS). However, during most of its existence, it was referred to as the Lighthouse Service.

Proving the importance of lighthouses, early lighthouse keepers were personally appointed by the president of the United States. In fact, our nation's first president, George Washington, personally appointed the first lighthouse keepers. However, over time, this changed and our nation's lighthouse system eventually evolved into a civil service organization.

As well as the lighthouse keepers that most people are familiar with, the Lighthouse Service had many other employees who served in a wide variety of positions. The Lighthouse Service was a large organization that had its own fleet of vessels, including lighthouse tenders and buoy tenders, as well as its own manufacturing plants, supply depots, fleets of trucks, engineers, clerks, draftsmen, masons, carpenters, inspectors, machinists, clerks, and even its own police force. According to one official of the Lighthouse Service, the organization had more employees, decentralized outside of Washington, D.C., than any other government agency. By 1924, the USLHS, with its well-developed system of aids to navigation, was the largest lighthouse organization in the world.

However, modern inventions and an ever-changing government brought an end to a way of life that many of the old-time lighthouse keepers could never have imagined. The first change came with trains, followed by changes in shipping routes, the use of electricity, ocean buoys, and of course, things like radar and sonar. However, the Lighthouse Service was slow to change and automation of lighthouses came at a slow pace, mainly from public objections to removing lighthouse keepers from lighthouses. In the 1930s, some discontinued light stations were sold at auction to private owners and have remained in private ownership ever since. Rarely were they offered to the community or local nonprofits.

The biggest and most dramatic change came in 1939 when Congress, under Pres. Franklin Roosevelt's reorganization plan, dissolved the Lighthouse Service by merging it into the U.S. Coast Guard. It was the first time in history that a military branch of the government took over a civilian agency of the government.

The U.S. Coast Guard brought a different attitude to the lighthouses, and eventually family lighthouse stations were phased out, as were many lighthouses that were no longer needed. When the U.S. Coast Guard took over the Lighthouse Service, the lighthouse keepers were given a choice of remaining on as civilian keepers or joining the U.S. Coast Guard. They split nearly evenly in their decisions. However, as civilian keepers retired, they were replaced with U.S. Coast Guard personnel.

Eventually all lighthouses were automated, and lighthouse keepers were removed. In many cases, discontinued light stations were abandoned and boarded up; some had the keepers' homes destroyed, and only the tower was left to display an automated beacon. A few keepers' homes at the more hospitable stations were kept as U.S. Coast Guard housing.

It was not until the late 1980s that many people suddenly realized that we were losing more of our lighthouse history than we were saving. Lighthouse preservation groups were formed to try to save some of these structures, but the cost was high.

The U.S. Coast Guard did save some structures at lighthouses, especially those that were in popular areas, and it stabilized others, but their limited budget did not allow for historic preservation. Instead money from its budget was to be used for law enforcement and keeping our nation's waterways safe and clean. Although the U.S. Coast Guard still maintains all the aids to navigation, the function, in the case of lighthouses, could be done less expensively through modern aids to navigation and not maintaining historic buildings.

In 1998, the Island Institute in Rockland, with the cooperation of the U.S. Coast Guard, developed the Maine Lights Program, which found new preservation owners for many of Maine's lighthouses. That program led Congress to pass the National Historic Lighthouse Preservation Act of 2000, which essentially allowed lighthouses, as they were being excessed, to be turned over, for free, to other government agencies or nonprofits. It also allowed for nonprofit preservation groups to compete on equal footing for ownership of a lighthouse. If neither a nonprofit nor other government agency wanted a particular lighthouse, it would then be put up for auction to the highest bidder. Eventually all lighthouse structures will not be owned by the U.S. Coast Guard. Instead other government agencies, nonprofits, or private individuals will own them. However, if a beacon still shines from the tower, the U.S. Coast Guard will continue to maintain the actual light mechanism.

Unfortunately, many of the photographs of lighthouse keepers and the families that lived at lighthouses have been destroyed or lost over time, while others remain to be rediscovered. Locating old photographs of lighthouse keepers is a difficult and time-consuming task. Many families of lighthouse keepers are unaware that preservationists and historians are looking for photographs, and others may not even know they have them.

However, it was the lighthouse keepers, with the help of their families, who kept the lights shining for the safe passage of ships, lives, and commerce that helped our developing nation grow into the great power that it is today.

It is vital to save the photographs and memories of these people so that future generations may understand how we developed into the great nation that we are today.

One

BAKER ISLAND
LIGHTHOUSE

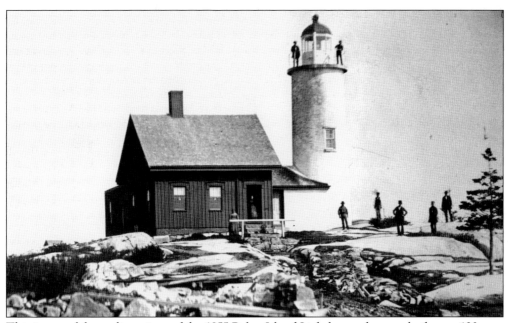

This is one of the earliest views of the 1855 Baker Island Lighthouse that was built on a 123-acre island about four miles from Mount Desert Island to replace an earlier 1828 wooden tower. It was built on the highest point of land, which allowed its beam of light to be easily seen by mariners to warn them of the dangerous ledges and nearby sandbar, as well as mark the southwestern approach to Frenchman's Bay. In 1828, William Gilley was appointed the first keeper at Baker Island Lighthouse, a position he held until 1848 when he was fired for not supporting the Whig Party that had come into power after the election. Although Gilley left the island, for a number of years, his sons harassed the succeeding keepers, claiming that they owned the island. Eventually the government won a court case assuring federal ownership of 19 acres of the island. (Courtesy Lighthouse Digest.)

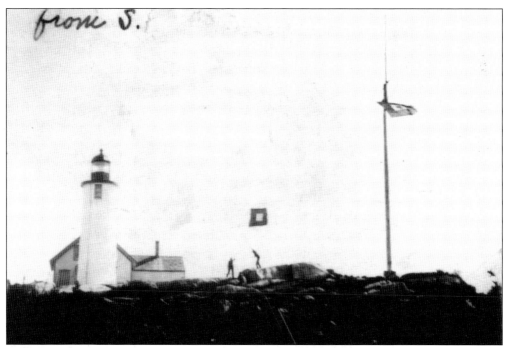

The government may have been testing a system of signal flags at Baker Island Lighthouse. The flags must have proved less than useful as no other photographs showing the signal flags at the lighthouse have surfaced. (Courtesy U.S. Coast Guard.)

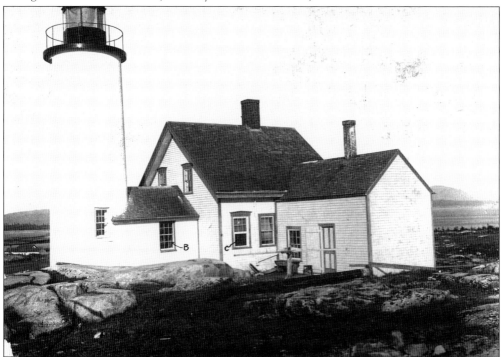

This rare image shows the back of the keeper's house. In later years, the enclosed walkway from the house to the tower was removed. (Courtesy U.S. Coast Guard.)

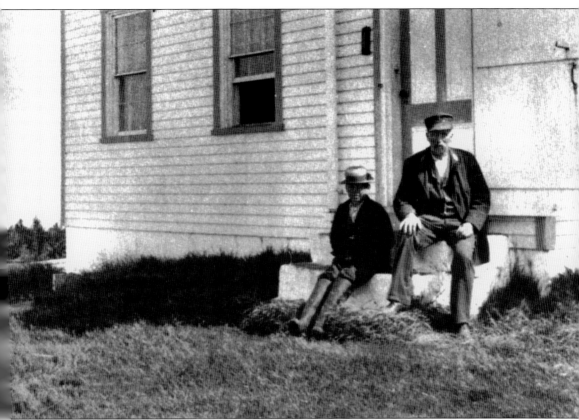

Capt. Howard P. Robbins, shown here with an unidentified person, served as the lighthouse keeper at Baker Island Lighthouse from 1888 to 1902. Robbins had a lengthy career in the Lighthouse Service. He also served as the second assistant keeper at Mount Desert Rock Lighthouse from 1872 to 1882. After Baker Island Lighthouse, he was transferred to Rockland Breakwater Lighthouse in Rockland where he retired at age 71 in 1909. Interestingly, one of Robbins's children married one of the children of Vurney King, who also served as a keeper at Baker Island lighthouse from 1915 to 1928. (Courtesy Harold Robbins.)

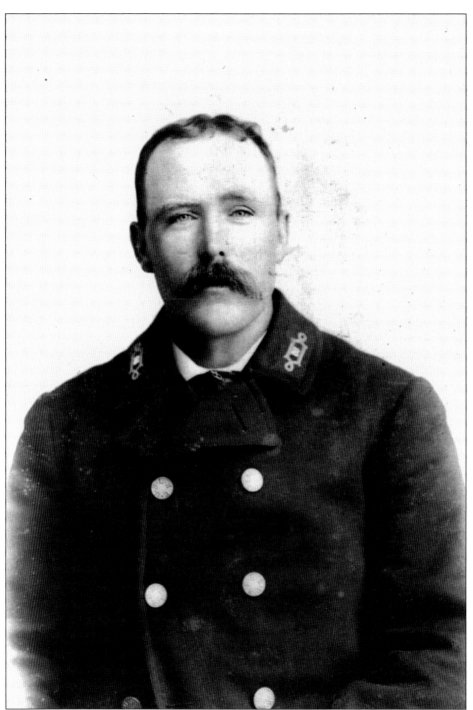

George Conners (1860–1914) served as the lighthouse keeper at Baker Island Lighthouse from 1902 to 1912. The number 2 on his jacket lapel indicates that this photograph was taken when he was the second assistant keeper at Whitehead Lighthouse, where he served from 1899 to 1902. His brother Edmund was also a lighthouse keeper, but served at Petit Manan Lighthouse off the coast of Milbridge. (Courtesy Carol Moffatt.)

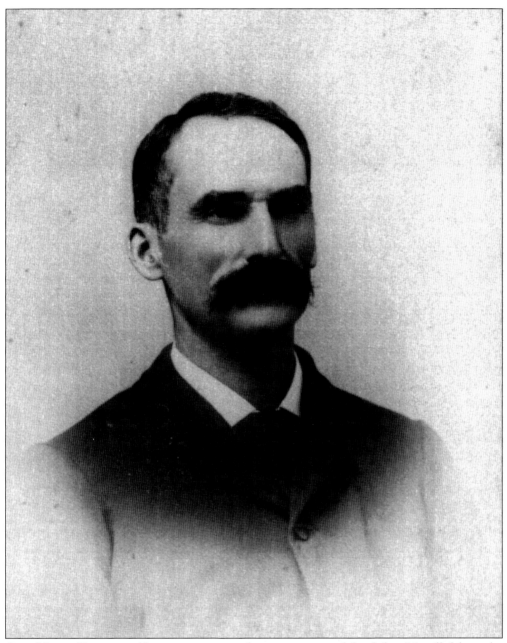

Capt. Vurney King started his maritime career by going to sea with his father, Merrill, fishing the waters off the Grand Banks. When he married Maude Kaler of Tremont, he joined the Lighthouse Service and began an 11-year stint at Saddleback Ledge Lighthouse as second assistant keeper, eventually working his way up to head keeper. Sometime around 1912, he was appointed the keeper at Baker Island Lighthouse where he served for 15 years. Being an ingenious keeper, Captain King brought an automobile out to the lighthouse to make his transportation easier around the 123-acre island. (Courtesy Harold Robbins.)

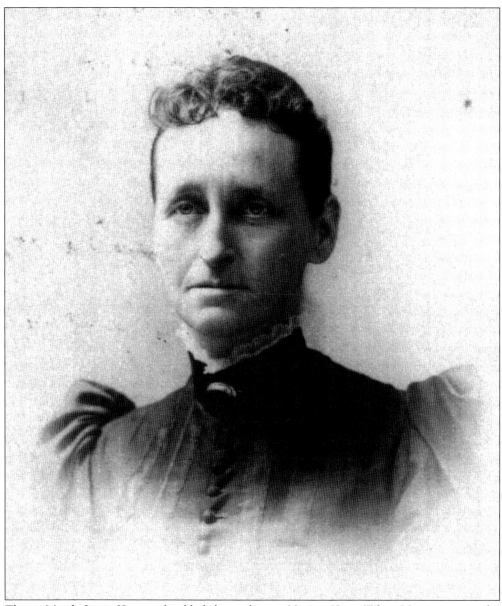

This is Maude Lizzie King, wife of lighthouse keeper Vurney King. When Vurney accepted a transfer to Dice's Head Light in Castine, he became the last official keeper of the lighthouse. After Vurney's retirement from the Lighthouse Service, Maude accepted the job as caretaker/custodian of Dice's Head Lighthouse. (Courtesy Harold Robbins.)

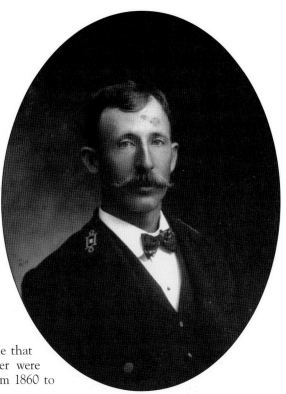

Very little is known about the short time that John Elisha and Hannah Marie Bunker were stationed at Baker Island Lighthouse from 1860 to 1861. (Courtesy Lighthouse Digest.)

It was his lighthouse keeper brother-in-law who convinced Joseph Muise to join the Lighthouse Service. Apparently it was wise advice, as Muise went on to serve as a lighthouse keeper for 25 years, first with the Lighthouse Service and then with the U.S. Coast Guard. Married to Annie Seavey, they raised six children at lighthouses, a life that had its happiness as well as tragedy. In November 1932, as Annie was going into labor, a boat was launched to get her to the mainland to a doctor. However, the baby had no intention of waiting and was delivered in the boat about two miles from the mainland. When their oldest child drowned at Baker Island Lighthouse in 1936, Muise requested a transfer and was sent to Moose Peak Lighthouse, a station he had previously served. He retired as a lighthouse keeper in 1951. (Courtesy Ann L. Muise and Lighthouse Digest.)

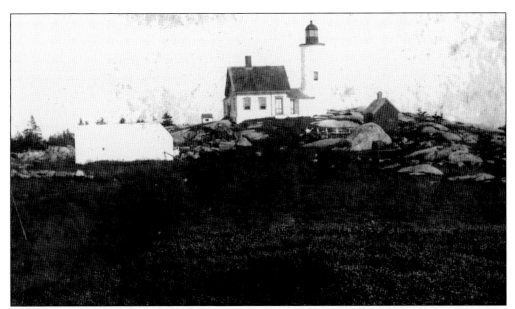

Although the government's lighthouse tenders would bring a supply of flour and other food staples, often pickled in barrels, it was never enough food to feed the family through the season. Crudely constructed outbuildings served as the first barns for the farm animals kept by the lighthouse keepers. At Baker Island Lighthouse, the keepers had pigs, sheep, cows, ducks, and chickens. They also maintained a large garden for the family. The keeper's house had a dirt-floor cellar where the vegetables were stored for the winter months. (Courtesy U.S. Coast Guard.)

Wayne Holcomb was the U.S. Coast Guard keeper at Baker Island Lighthouse from 1944 to 1945. He lived at the station with his wife, Harriett. (Courtesy Velna Holcomb Pennington and Lighthouse Digest.)

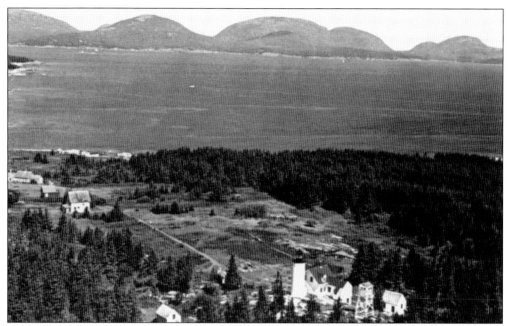

This aerial view of Baker Island Lighthouse shows how large the lighthouse station had become over the years with a number of well-maintained buildings. It also shows the home of some of the summer residents. Since the 43-foot brick tower was built on the highest point of land on the island, it was quite a distance from the shoreline. (Courtesy U.S. Coast Guard.)

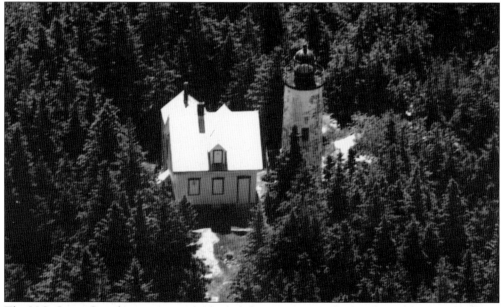

The U.S. Coast Guard now owns only the lighthouse tower and a one-foot wide section of land around the tower; the rest of the ownership of the site was transferred to the National Park Service. Over time, hundreds of trees have grown up around Baker Island Lighthouse, making it useless to mariners at sea. However, officials of Acadia National Park have stated that cutting down all the trees, which would be required to make the light visible again to mariners, is beyond their budgetary capabilities. (Courtesy Ron Foster.)

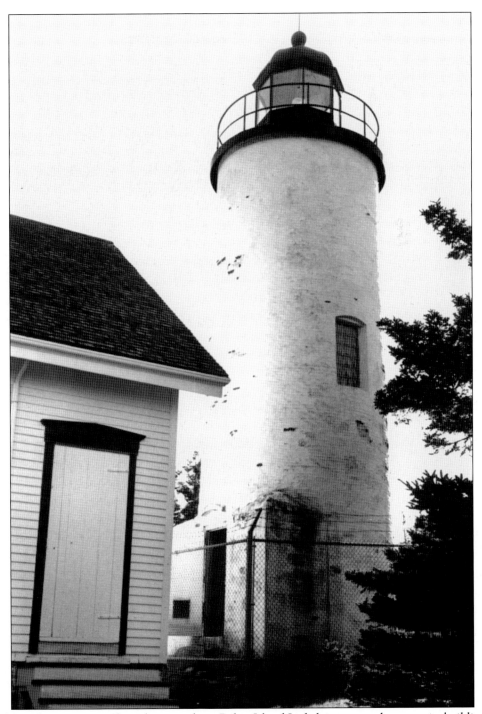

Although some repairs have been made to Baker Island Lighthouse over the years, its buildings continue to deteriorate. A number of years ago, the U.S. Coast Guard planned some restoration of the tower but could not gain permission to clear an area around the tower for the necessary staging. (Courtesy Stephen Rappaport.)

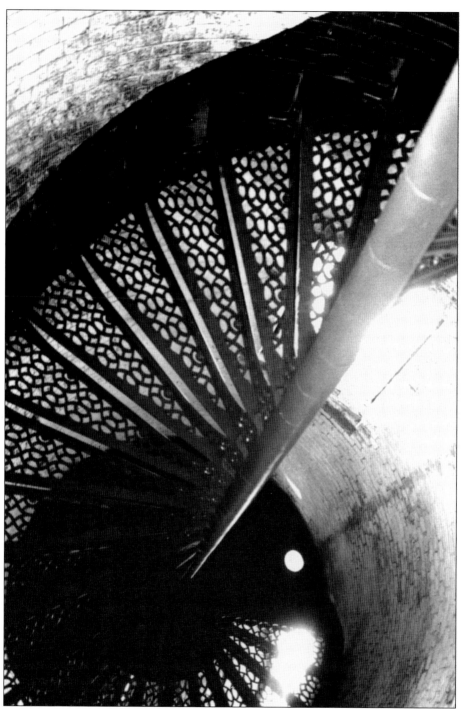

Some 43 spiraling wrought iron steps lead to the top of Baker Island Lighthouse. The keeper climbed the stairs at dusk each day to light the wick and climbed back up each morning to extinguish it. When the lighthouse was automated in 1966, the rare Fresnel lens was removed from the tower and replaced by a modern optic. The old Fresnel lens was given to the Fisherman's Museum at Pemaquid Point Lighthouse in Bristol. (Courtesy Stephen Rapport.)

Two

BASS HARBOR
HEAD LIGHTHOUSE

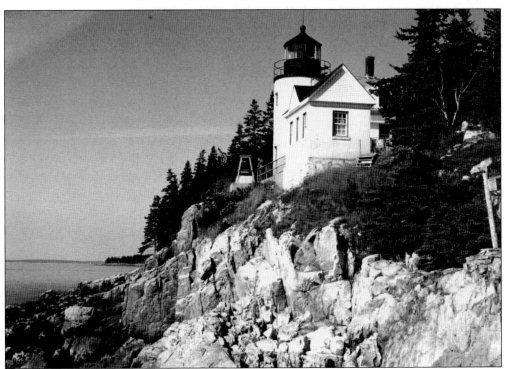

Built in 1858, the Bass Harbor Head Lighthouse, the only lighthouse on Mount Desert Island, was built to warn mariners of the Bass Harbor Bar and to mark the southeast entrance to Blue Hill Bay. Although it is remote, its scenic location makes it one of the most photographed lighthouses in New England. On nearly any given day, the parking lot at the lighthouse is full, as people hike the trail down to the water's edge to photograph the lighthouse, which sits majestically atop colorful and unique rock formations. (Courtesy Lighthouse Digest.)

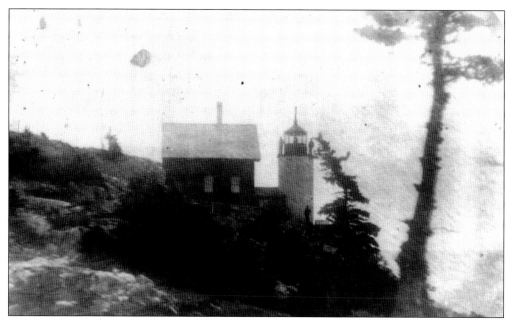

This is one of the earliest photographs of Bass Harbor Head Lighthouse. The first keeper was John Thurston, who lived here with his family from 1858 to 1861. Despite its beautiful location, early life at the lighthouse was difficult in this remote location, and Thurston and the subsequent three lighthouse keepers stayed only three to four years at a time. (Courtesy Lighthouse Digest.)

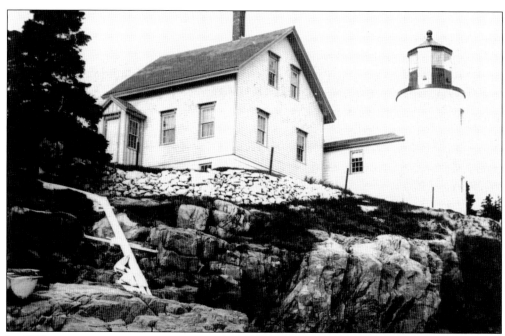

In 1902, extensive renovations were made to the keeper's house when a larger kitchen and additional rooms were added and the original siding was replaced. However, by comparison to many other Maine lighthouses, the station here was very plain and simple. However, its photogenic location made up for the simple design of the structure. (Courtesy U.S. Coast Guard.)

Capt. Joseph M. Gray, who joined the United States Lighthouse Service (USLHS) in 1898, finished his career as the lighthouse keeper at Bass Harbor Head Lighthouse where he served from 1921 to 1938. Since most of his previous assignments had been at offshore lighthouses, he considered life good at Bass Harbor Head Lighthouse. He retired to a snug little cottage in Tremont. (Courtesy Dorothy Gray and Gunther Meyer.)

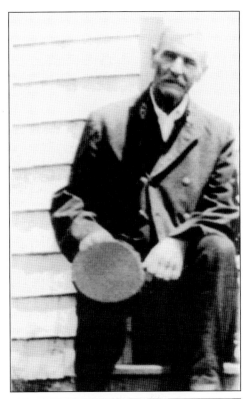

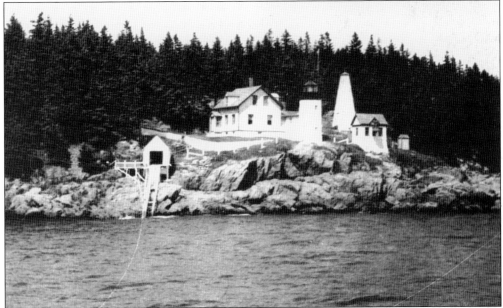

The tall pyramid-shaped building to the right of the lighthouse tower housed the fog bell. This building no longer stands, having been replaced by a fog bell building, shown in front of it, that still stands today. The small boathouse to the left was added to the station in 1894, but landing here by boat was always difficult. A winch was used to pull the heavy station boat up into the structure. (Courtesy National Archives.)

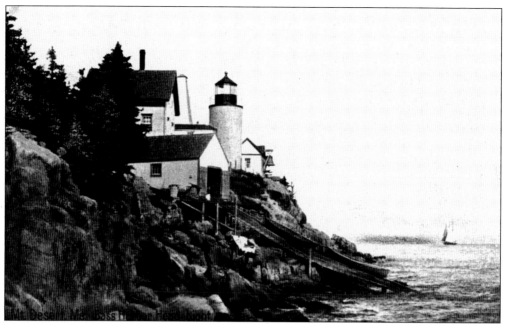

This vintage postcard shows how difficult it was to haul the boat up the ramp at Bass Harbor Head Lighthouse using a hand winch. The lighthouse tender, anchored offshore, would deliver supplies via small dories that then went to shore and were hauled up the boat ramp for the supplies to be unloaded. As the roads to the lighthouse improved and modernization came to the lighthouse, the boathouse was deemed no longer necessary, and it was demolished. (Courtesy Lighthouse Digest.)

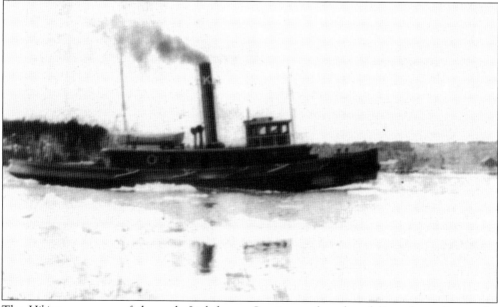

The *Hibiscus* was one of the early Lighthouse Service tenders that delivered supplies to the lighthouse family at Bass Harbor Head Lighthouse. The crew also delivered the rotating library of reading materials and newspapers from the big cities. Lighthouse keeper C. L. Knight, who served at a number of Maine's lighthouses, took this image. (Courtesy Lighthouse Digest.)

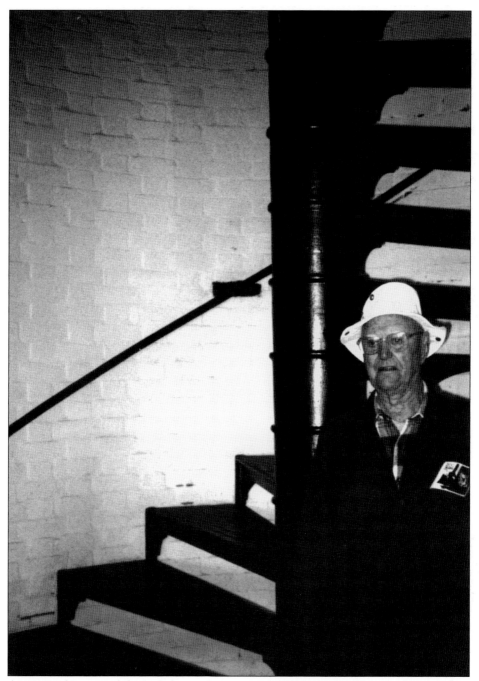

Harlan E. Sterling joined the Lighthouse Service in 1934 when he was 17 years old. He served on board the lighthouse tender *Hibiscus* until 1939. As well as delivering supplies to the lighthouses in the Bar Harbor and Acadia region, the tender also maintained many of the ocean and harbor buoys. Before being transferred to a buoy tender in Puerto Rico, Sterling also served short stints as a relief lighthouse keeper at a number of lighthouses. When the U.S. Coast Guard took over the Lighthouse Service, he joined the U.S. Coast Guard and served until his retirement in 1965. (Courtesy Lighthouse Digest.)

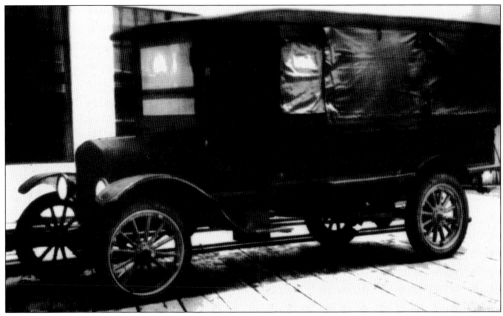

Although it was rare for the Lighthouse Service to send a truck with supplies to a lighthouse, there were instances when this happened, especially as roads became more usable, particularly in remote areas. (Courtesy Lighthouse Digest.)

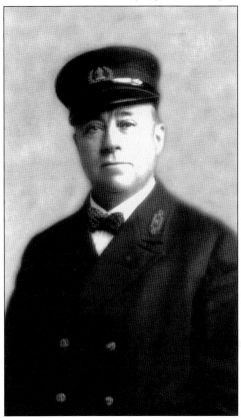

Arriving at Bass Harbor Head Lighthouse in 1938, Elmer Reed had a long career as a lighthouse keeper, having served at a number of Maine lighthouses, including 19 years at Curtis Island Lighthouse before he was transferred in 1938 to Bass Harbor Head Lighthouse. Reed was the lighthouse keeper at Bass Harbor Head Lighthouse when the Lighthouse Service was dissolved and merged into the U.S. Coast Guard. Since he joined the U.S. Coast Guard at that time, he then became the first U.S. Coast Guard keeper to serve at Bass Harbor Head Lighthouse. Interestingly, he was not the last civilian lighthouse keeper of the old USLHS to serve there. That distinction went to veteran keeper Morton M. Dyer, who arrived here in 1955. When the U.S. Coast Guard took over the Lighthouse Service, Dyer declined to join the U.S. Coast Guard and remained a civilian lighthouse keeper. He retired at age 70 from Bass Harbor Head Lighthouse. (Courtesy Ted Panayotoff.)

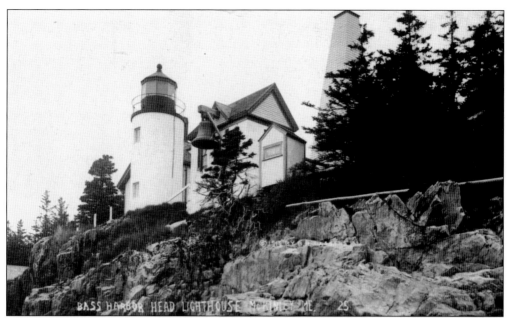

By the time this photograph was taken, the old pyramid fog bell tower at Bass Harbor Head Lighthouse was no longer in use. The new automated fog bell house, with the bell hanging outside the structure, had replaced it. Next to the fog bell house is the privy, which was more often referred to by the keepers as the "Necessary." The structure no longer stands. (Courtesy Lighthouse Digest.)

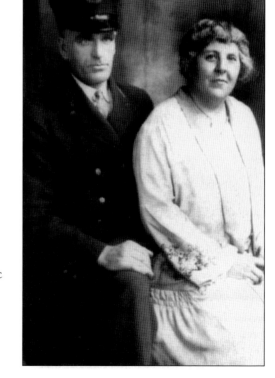

Eugene Coleman, shown here with his wife, Poise, had a long and illustrious career as a lighthouse keeper. As well as serving at Bass Harbor Head Lighthouse, he served at Doubling Point Lighthouse on the Kennebec River and at Nubble Lighthouse in York, where he gained some notoriety of sorts with the lighthouse cat, Sambro, who often swam the channel between the lighthouse and the mainland. (Courtesy Don and Deb Malonson.)

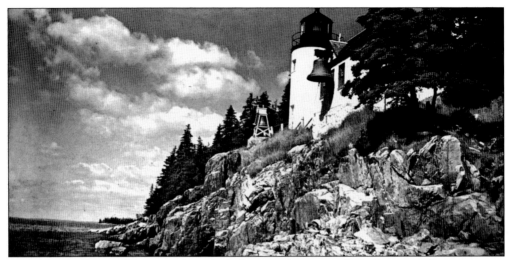

The old fog bell was still hanging from the bell tower when a new fog bell, mounted on a cast-iron frame, was installed in front of the lighthouse tower at Bass Harbor Head Lighthouse. The new bell on the cast-iron frame was rung using an automatic bell striker, which was an apparatus that looked much like a large sledgehammer. A similar cast-iron frame and fog bell with the striking mechanism is on display at the Maine Lighthouse Museum in Rockland. (Courtesy Lighthouse Digest.)

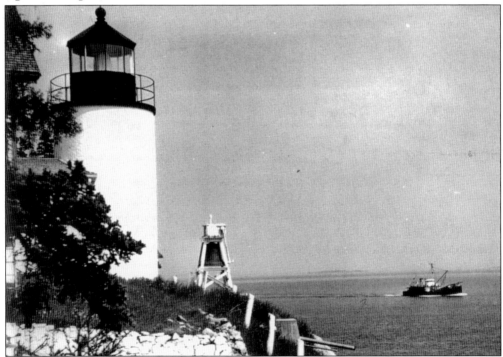

It is believed that the U.S. Coast Guard buoy tender shown traversing in the waters past Bass Harbor Head Lighthouse in this 1956 image is the *White Heath*, a former naval vessel that was acquired by the U.S. Coast Guard in the late 1940s and refitted as a buoy tender. The vessel was decommissioned in 1998 and transferred to the country of Tunisia, a small nation in North Africa. (Photograph by J. H. Swint, courtesy Lighthouse Digest.)

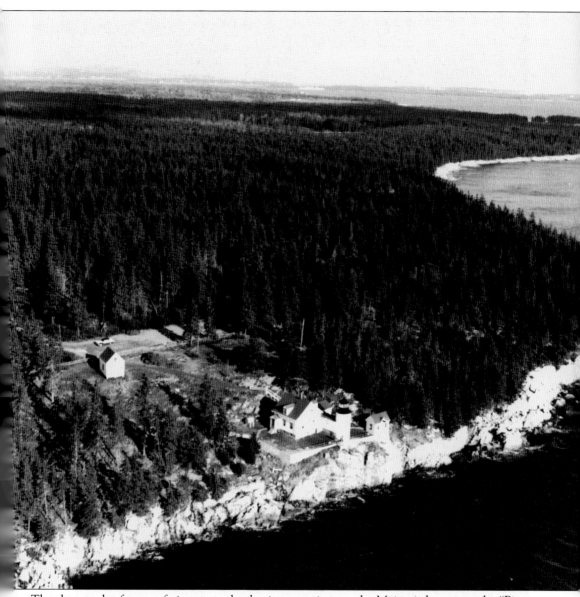

The thousands of acres of pine trees clearly give meaning to why Maine is known as the "Pine Tree State." This image from the late 1950s shows one lonely car in the parking lot as it was about to depart, which is very rare here in the tourist season. The keeper's house remains the private residence of a U.S. Coast Guard family. However, in the summer months, with an average of 1,000 tourists visiting every day, the U.S. Coast Guard family must share this beautiful location with many others. Fortunately, they have a fence around the house to protect their privacy. (Courtesy U.S. Coast Guard.)

One of the old lighthouse dories from Bass Harbor Head Lighthouse is on display, welcoming visitors today to the area. Rowing a heavy boat like this, especially when it was loaded with supplies for the lighthouse, must have been a difficult task, much different than today with outboard engines. (Courtesy Lighthouse Digest.)

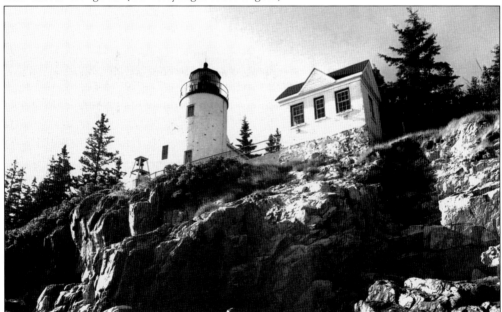

A photograph of Bass Harbor Head Lighthouse from this angle can only be taken at low tide. The building to the right of the tower was the second fog bell building. The bell shown in previous photographs is no longer there. It is easy to understand why so many calendars feature images of Bass Harbor Head Lighthouse. (Courtesy Lighthouse Digest.)

Three

BEAR ISLAND LIGHTHOUSE

Bear Island Lighthouse is located on the southeast point of Bear Island, which is one of the islands in the Cranberry Isles near the town of Northeast Harbor on Mount Desert Island. This old stereo-view image by B. Bradley is of the second tower built here. The first tower, built in 1839, was destroyed by fire in 1852. It was replaced by a brick tower in 1853 that was replaced again in 1890. (Courtesy Lighthouse Digest.)

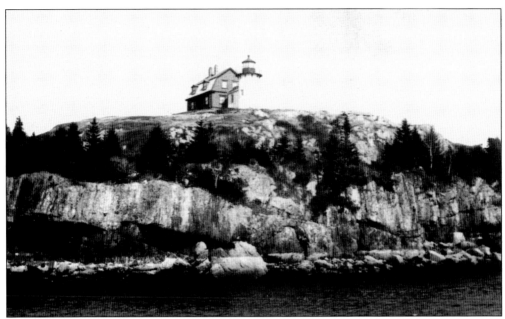

When the old keeper's house at Bear Island Lighthouse was demolished in 1889, it was replaced by a new and more practical building. This image also shows the new tower and lantern room at the station. The station rests atop a sheer cliff on the southeast corner of the island. Although the tower is only 31 feet high, it looks like a majestic structure when viewed from the water. (Courtesy U. S. Coast Guard.)

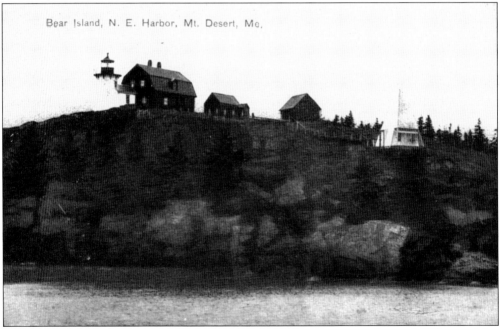

Bear Island, N. E. Harbor, Mt. Desert, Me.

The pyramid fog bell tower was built in the late 1800s to accommodate a 1,000-pound fog bell. In the early days, because of the great importance of fog bells, many people felt that the name of a lighthouse should have also included the words "Fog Bell Station." (Courtesy Lighthouse Digest.)

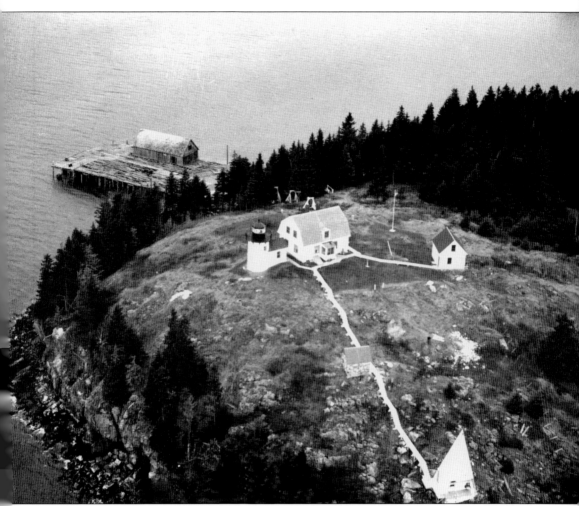

In Maine, the primary lighthouse depot was located on Little Diamond Island in Portland Harbor. It was from there that all supplies were shipped to the various lighthouses and where ocean buoys were stored and repaired. In 1886, the lighthouse inspector recommended, "that a coal shed of a capacity of 300 to 400 tons be built on the wharf at Bear Island Light Station. A supply of coal at this point will greatly facilitate the work of the district." The coal station and buoy docks, built in 1887, were in use for a number of years until those duties were transferred to the new lighthouse depot in Southwest Harbor, which is now a U.S. Coast Guard station. The old buoy and coal docks, seen in the upper left of the photograph, are in a state of disrepair after they had been abandoned. (Courtesy Lighthouse Digest.)

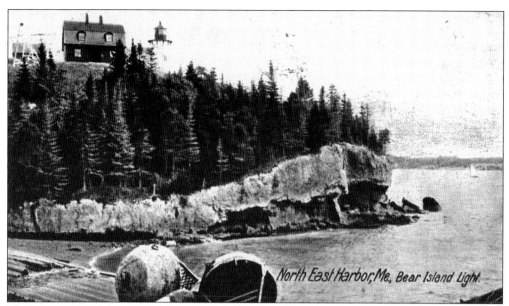

This rare postcard from 1908 shows some old buoys lying on the buoy dock on the shoreline at the lighthouse depot, with Bear Island standing proud above the docks. The buoys were stored here while they were repaired or refurbished to be picked up by the buoy tender and placed back in the ocean. (Courtesy Lighthouse Digest.)

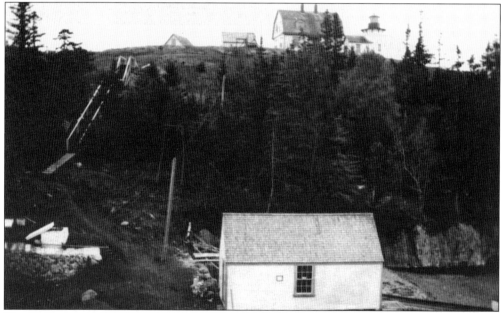

The boathouse at Bear Island Lighthouse was quite a distance from the keeper's house at the top of the hill. Supplies had to be brought in the small boat, which was then hauled up the boat ramp. From there, the supplies, which would have included food staples, some of it in barrels, oil for the lamps, books, and everything else, had to be brought up a dirt path to an inclined wood walkway, then up the sections of stairs, and finally on an uphill hike across the lawn to the keeper's house. Moving a lighthouse keeper's belongings must have been quite a project. (Courtesy Lighthouse Digest.)

USLHS lighthouse keeper Lewis F. Sawyer lived at Bear Island Lighthouse with his family from 1899 to 1909. He was the first keeper to live in the new keeper's house, which still stands to this day. He had previously been the lighthouse keeper at Egg Rock Lighthouse from 1889 to 1899. Coincidently, his son Heber Sawyer also served as a lighthouse keeper at both of these lighthouses. (Courtesy American Lighthouse Foundation.)

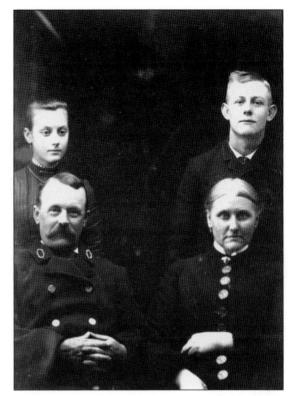

Since a photographer in Southwest Harbor took this photograph, this unidentified but distinguished-looking lighthouse keeper may have served at Bear Island Lighthouse or one of the nearby lighthouses. The letter K on his jacket lapel indicates that he was a head lighthouse keeper. His pocket watch has a Masonic emblem surrounded by a horseshoe. He might also have served as the keeper of the lighthouse depot in Southwest Harbor. (Courtesy Lighthouse Digest.)

In the 1930s, Elmo J. Turner served as the lighthouse keeper at Bear Island Lighthouse, after previously having served as the keeper at Great Duck Island Lighthouse. Like many other lighthouse keepers, Turner and his family kept a cow and chickens on the island. Reports indicate that the cow got seasick on a trip off the island. Turner's sons, Claude and Elmo, somewhat followed in their father's footsteps and served in the U.S. Coast Guard on board buoy tenders. (Courtesy Lighthouse Digest and Joyce MacIlroy.)

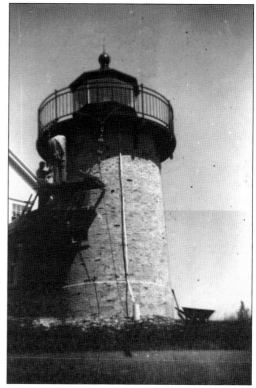

A U.S. Coast Guard crew standing on a suspended platform is doing repairs to Bear Island Lighthouse in the late 1940s. (Courtesy Lighthouse Digest.)

In 1946, the U.S. Coast Guard distributed this photograph, with what was meant to be a humorous headline reading "Light-House Keeping" to the news media with the following caption, "Once over lightly is the order for the day at Bear Island Lighthouse off the Coast of Maine, as Mrs. Andrew W. Kennedy, wife of the U.S. Coast Guard keeper, gives the windows of the light their daily cleaning." The news media apparently loved it, and the photograph was published in hundreds of newspapers across the country. (Courtesy Lighthouse Digest.)

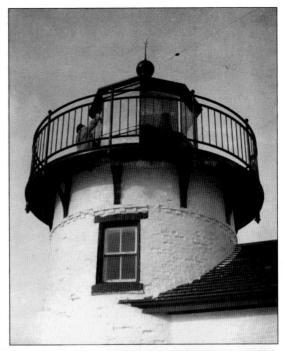

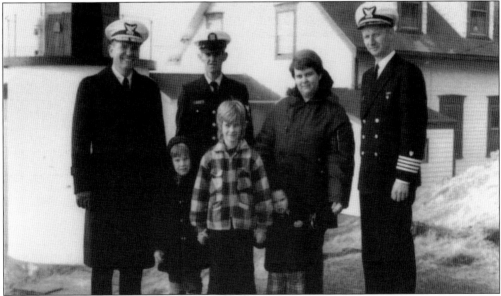

In this mid-1970s photograph, the adults are, from left to right, Adm. J. P. Stewart, commander First Coast Guard District; U.S. Coast Guard lighthouse keeper John Baxter; John's wife, Gail; and Group Commander Smith. The Baxter children, from left to right, are John, Kim, and Stephen. Although this photograph was taken at Maine's Browns Head Lighthouse in Vinalhaven, the Baxters were stationed at Bear Island Lighthouse in the 1960s, when John was assigned there as a relief keeper. He also served at Mount Desert Rock Lighthouse. John joined the U.S. Coast Guard in 1958 and retired after 23 years of service. The Baxters' son Stephen was actually born in the keeper's house at Browns Head Lighthouse. (Courtesy Lighthouse Digest and John and Gail Baxter.)

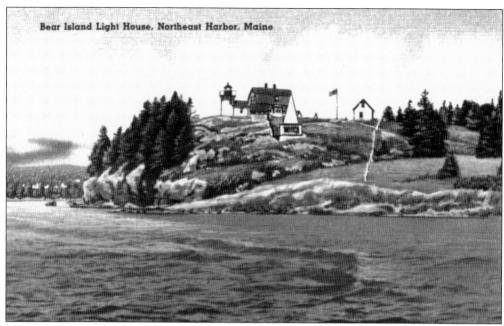

Bear Island Light House, Northeast Harbor, Maine

Bear Island Lighthouse is shown here in its heyday. At this time, all the buildings were in immaculate condition, and the grass was cut. However, after the lighthouse was automated and its keepers were removed, it was abandoned by the U.S. Coast Guard and quickly fell into a state of disrepair. (Courtesy Lighthouse Digest.)

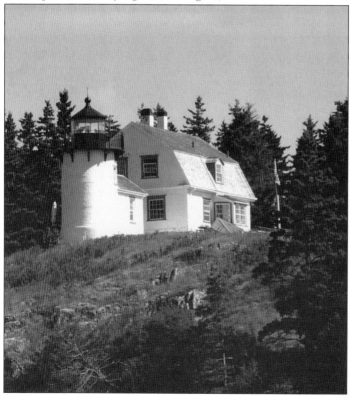

In 1987, ownership of Bear Island Lighthouse was transferred to Acadia National Park, and in 1989, the Friends of Acadia spent some money refurbishing the lighthouse and relit the tower as a private aid to navigation. The lighthouse station is now leased to a private individual who has meticulously restored the property. (Photograph by Al Bishop, courtesy Lighthouse Digest.)

Four

BURNT COAT
HARBOR LIGHTHOUSE

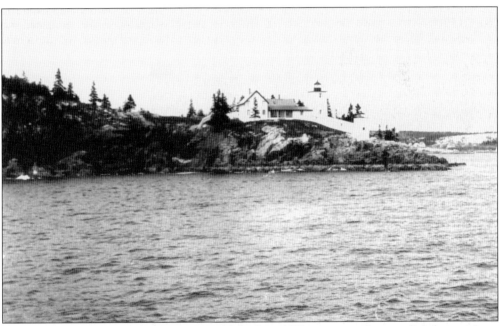

Burnt Coat Harbor Lighthouse was established in 1872 as a set of range lighthouses on a promontory called Hockamock Head on the 7,000-acre Swans Island to guide ships into the harbor. Because of its location, the lighthouse is also often called Hockamock Head Lighthouse or Swans Island Lighthouse. The island was named after James Swan, who in 1786 obtained the deed for Burnt Coat Island and all the islands within three miles of it. Swan was an ardent member of the Sons of Liberty, took part in the Boston Tea Party, and fought at the Battle of Bunker Hill, and built a lavish home on the island that he was never able to live in. In 1808, he was sent to debtors' prison in France where he lived for 22 years before he was freed in 1830 by revolutionary decree. (Courtesy U.S. Coast Guard.)

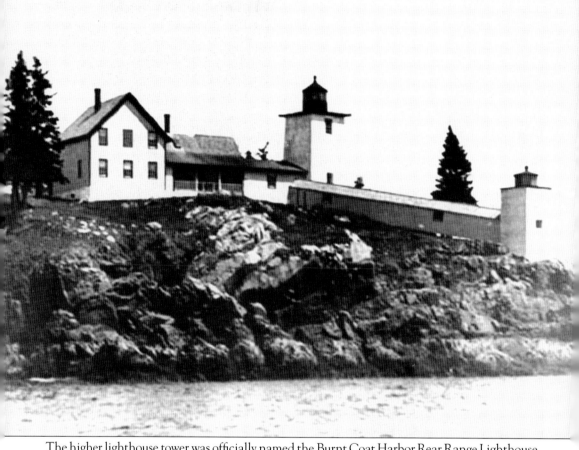

The higher lighthouse tower was officially named the Burnt Coat Harbor Rear Range Lighthouse, and the lower tower was named the Burnt Coat Harbor Front Range Lighthouse. The two towers were connected by an enclosed walkway that offered the keeper protection in keeping the lights burning during inclement weather. However, after numerous complaints from mariners that the beacons from the two lighthouse towers were confusing, the front tower was discontinued in 1884. Frank Milan, son of lighthouse keeper Orrin Milan, recalled the demise of the Burnt Coat Harbor Front Range Lighthouse when he wrote, "They just put jacks under the back side and just toppled the tower into the brink." (Courtesy Lighthouse Digest.)

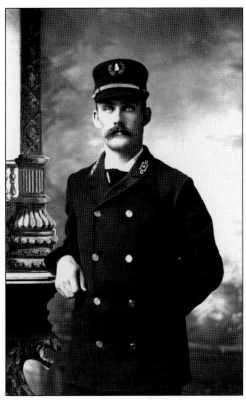

Orrin and his wife, Nettie, came to Burnt Coat Harbor Lighthouse in 1897 after serving a number of years on the inhospitable Mount Desert Rock Lighthouse. Life at Burnt Coat Harbor Lighthouse apparently suited the family quite well, and they kept the lighthouse here for an amazing 35 years until Orrin's retirement in 1935. Orrin was the keeper when the old abandoned Burnt Coat Harbor Front Range Lighthouse was destroyed. The number 2 on his jacket lapel indicates that these photographs were taken between 1882 and 1895, while he was the second assistant keeper at Mount Desert Rock Lighthouse and before he was appointed the first assistant keeper and then promoted again and transferred as the head keeper at Burnt Coat Harbor Lighthouse. (Courtesy Marie Migner.)

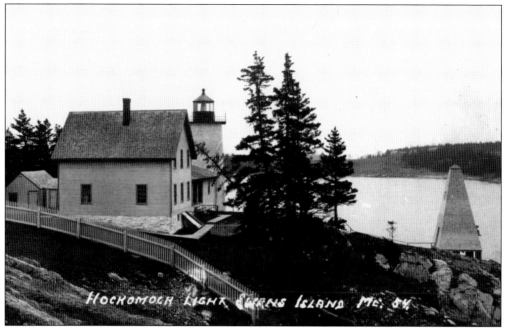

Hockomock Light Swans Island Me. 54

In 1912, a fog bell tower was built near where the old front light tower had once stood. In later years, keeper Orrin Milan's son, Frank, recalled, "This tower had to be quite high so they would have room to hoist the weights that would cause the bell to ring. As the weights would come down they would cause the striker to hit the bell, which would continue for over five hours. I have wound them up a good many times and you can take my word that it wasn't easy." (Courtesy Lighthouse Digest.)

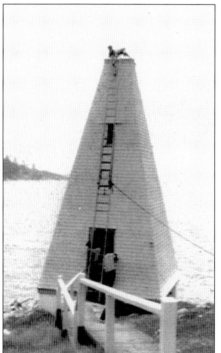

In 1935, when electricity came to the Burnt Coat Harbor Lighthouse, it was no longer necessary to have a bell tower operated by weights and pulleys. Workmen removed the weights and chains from the tower in preparation to permanently remove the top half of the tower. What would remain was the most unusual looking bell tower in all of Maine. (Courtesy Lighthouse Digest.)

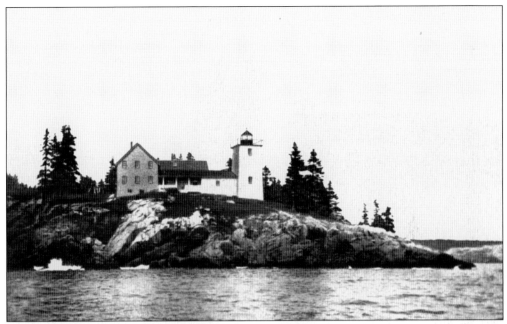

In July 1876, during the tenure of lighthouse keeper William N. Wasgatt, a Mr. Cutler and his wife visited the lighthouse. They took the lighthouse dory out for a ride with keeper Wasgatt's two daughters. Somehow or another, the dory capsized, tragically costing the life of Mr. Cutler's wife, who drowned. In later years, the enclosed walkway between the house and the tower was removed. (Courtesy Lighthouse Digest.)

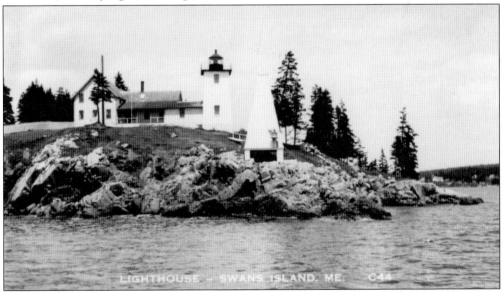

The Burnt Coat Harbor Lighthouse keeper's house was large and comfortable, and in the winter months, there was always plenty of coal in the coal shed for heat. However, in the summer months, the cistern often went dry, and the keeper had to row across the harbor and bring back drinking water for the family. Violent storms were also witnessed from the lighthouse tower, as when the *J. W. Sawyer* wrecked and sank here in March 1882. Of the crew, 12 were rescued and brought to the island but 3 of them lost their lives. (Courtesy Lighthouse Digest.)

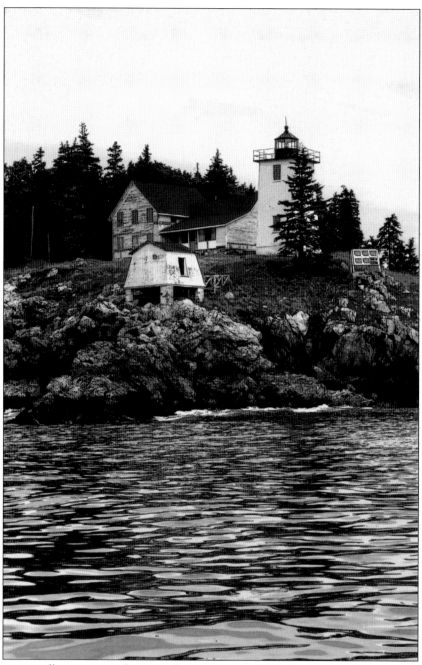

In 1982, reportedly to save on the cost of repainting, the U.S. Coast Guard removed the white paint from the tower and left the natural brick. However, local mariners complained that the tower was too hard to view as a daymark, and it was again painted white. In 1975, the Burnt Coat Harbor Lighthouse was automated and the last keeper left. The station was boarded up and left to the elements. The odd-shaped building at the water's edge is the base of the original fog bell tower. By this time, the fog bell was no longer in use and had been replaced by a fog whistle mounted at the top of the tower. The fog bell was donated to the local historical society. (Courtesy Ron Foster.)

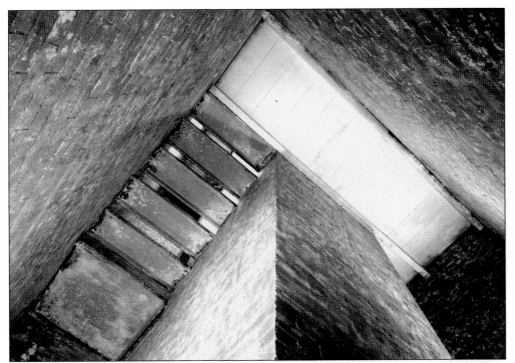

This photograph shows the interior of the tower at Burnt Coat Harbor Lighthouse from the first landing in the southwest corner looking northeast. In the days before electricity, the lighthouse keeper carried the oil up to the top of the tower every night to fill the lamp that would then light the lens to shine its beam out to sea. When the lighthouse was automated, the Fresnel lens was removed from the tower. Eventually a modern optic replaced it. (Courtesy Library of Congress.)

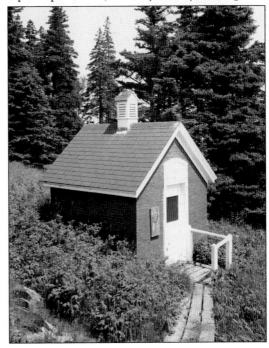

This is the brick oil house at Burnt Coat Harbor Lighthouse. In the early years, whale oil was stored here followed by kerosene, which was used to light the lamp in the tower as well as the lamps used in the keeper's house in the days before electricity. (Courtesy Library of Congress.)

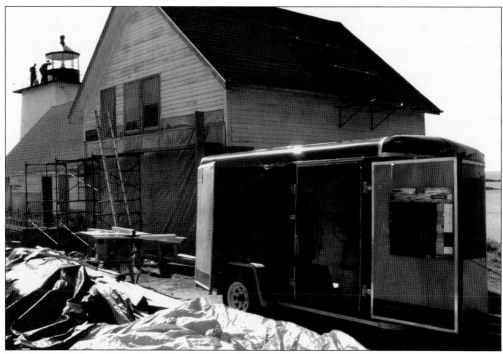

The Town of Swans Island was given ownership of the Burnt Coat Harbor Lighthouse in 1994. In 2006, it started the long process of restoration. (Courtesy Donna Wiegle.)

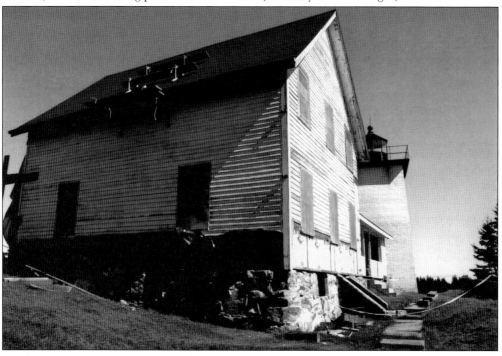

Five

EGG ROCK LIGHTHOUSE

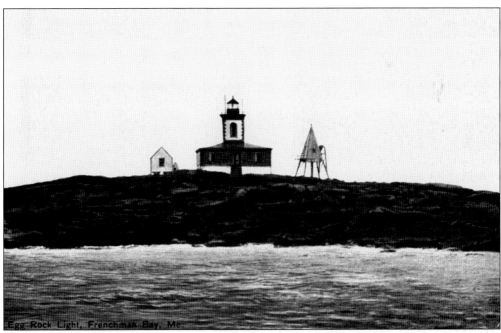

Egg Rock Light, Frenchman Bay, Me.

The popularity of Bar Harbor and the Acadia region as a tourist destination was the primary reason that in 1874 the government allocated funds for the building of a lighthouse on Egg Rock. Ambrose H. Wasgatt was the first lighthouse keeper. He stayed here 10 long years and experienced storms that would have forced the weaker at heart to leave the lighthouse and seek other employment. Although the living quarters were quite comfortable, the keeper would often wonder if the fog bell tower would still be there when waves would wash on the five-acre rocky island. During one storm, the bell tower and its heavy bell were moved 30 feet. Although the basic lighthouse structure still stands, with additions and improvements, it looks quite different today than it did in those early years. (Courtesy Lighthouse Digest.)

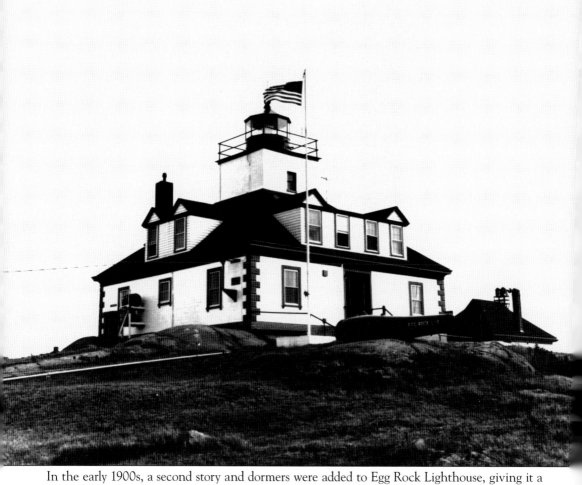

In the early 1900s, a second story and dormers were added to Egg Rock Lighthouse, giving it a much different appearance than the original structure. Looking closely, one will see a cannon resting on the lawn that was once part of a coastal defense battery that was on the island. The cannons are now on display near the beginning of the Bar Harbor Shore Walk. The station was in pristine condition when the light was changed from a fixed red beacon to a flashing red light. The old fog bell had now been replaced by steam-driven fog trumpets that can be seen protruding from the fog signal building. In 1908, during a major inspection by secretary of commerce and labor Oscar S. Straus and the secretary of the U.S. Lighthouse Board, Rear Adm. Adolph Marix, who was the first Jewish admiral in the U.S. Navy, the lighthouse station was found to be in good order. (Courtesy U.S. Coast Guard.)

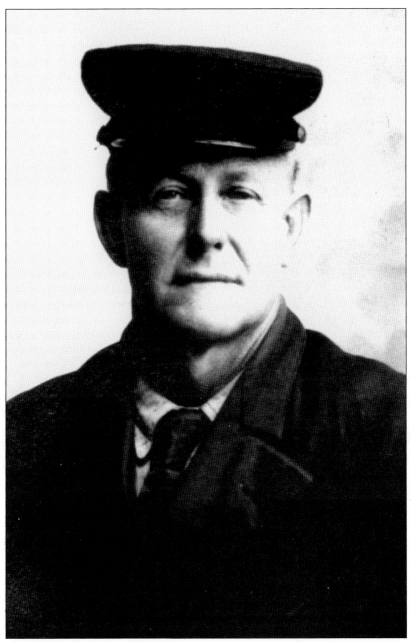

In 1899, after serving at Mount Desert Rock Lighthouse since 1887, then assistant lighthouse keeper Heber G. Sawyer replaced his father, Lewis F. Sawyer, who had served as the keeper of Egg Rock Lighthouse since 1888, when Lewis was transferred to Bear Island Lighthouse. At that time, the government discontinued the position of assistant keeper at Egg Rock Lighthouse, leaving Heber and his wife, Iona, to staff the lighthouse station on their own. During one storm, the keeper wrote that everything that was moveable was washed away, and the privy was moved from its location near the keeper's house to the boathouse. However, the keeper was thankful that the privy was still there. Eventually Heber was transferred to Bear Island Lighthouse where his father had also been the keeper before him. (Courtesy Alberta Willey.)

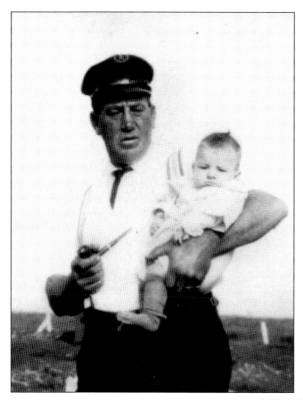

John Purington arrived at Egg Rock Lighthouse in 1905 as an assistant keeper to Heber Sawyer, who was then the head keeper. Because of Purington's growing family, he requested a transfer to a larger station, and in 1909, he was sent to Whitehead Lighthouse where he served until 1911. He was then sent to Deer Island Thorofare Lighthouse on Mark Island. In 1916, he was sent to Nash Island Lighthouse where he served until 1935. It was at Nash Island where he gained a sort of celebrity status among the locals of the community. (Courtesy Eva Denny.)

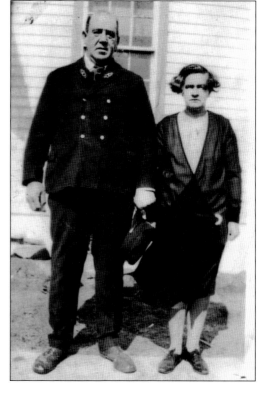

Genevieve (Jenny) Purington was one of the nine children of veteran lighthouse keeper John Purington. By the age of 10, she had her own lobster traps and while growing up at Nash Island Lighthouse started raising her own sheep, something she did for the rest of her life. In later years, she recalled many fond memories of island lighthouse life. Her brothers were active duck hunters, and they always had a fresh supply of meat to feed the family. As an adult, she purchased most of Nash Island where her lighthouse family had lived for 19 years. (Courtesy Eva Denny.)

Capt. Herman M. Ingalls is on the deck of the USLHS lighthouse tender *Ziziana* in 1917. His brothers Frank and Eugene were both lighthouse keepers, and brother Frank served as an assistant lighthouse keeper at Egg Rock Lighthouse in 1909. Eugene, a lighthouse keeper at Petit Manan Lighthouse, lost his life in 1917 when his boat capsized. Captain Ingalls eventually became the superintendent of the Second Lighthouse District. He passed away in 1965. (Courtesy Lois E. Sprague.)

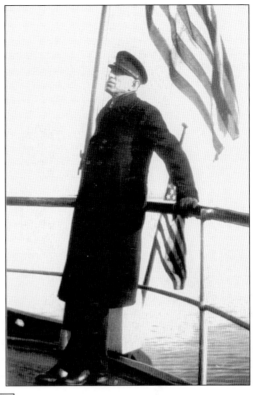

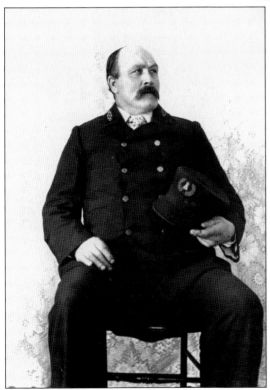

Being a lighthouse keeper was considered a prestigious job, and the men were proud to wear the uniform of the Lighthouse Service. Many of them often posed for professional photographs but oftentimes failed to write their names on the back of the image. With the passing of time, their identify was forgotten. The number 1 on the jacket lapel indicates that he was a first assistant keeper. (Courtesy Gail Upton Denbow.)

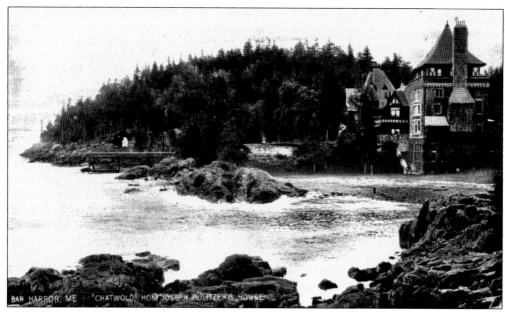

In 1893, Joseph Pulitzer of newspaper and Pulitzer Prize fame leased a gigantic summer home in Bar Harbor called Chatwold. A year later, he purchased the estate and began extensive renovation work. Being incredibly sensitive to noise, he spent $100,000 constructing what he called the "Tower of Silence" to keep out noise. However, he was infuriated by the sound of the foghorn from Egg Rock Lighthouse. Chatwold, which was located on Schooner Head Road, was demolished in 1944. (Courtesy Lighthouse Digest.)

In the early 1900s, a steam-powered air compressor foghorn that protruded from the fog signal building at Egg Rock Lighthouse replaced the fog bell. Pulitzer complained vigorously to have the foghorn shut off, which the government refused to do, but they did slightly change the direction of the horn in an attempt to appease him; however, its noise remained an annoyance to Pulitzer until his death in 1911. (Courtesy National Archives.)

Clinton "Buster" Dalzell and his wife, Elizabeth, started out their lighthouse career in 1930 when they got married at Maine's Heron Neck Lighthouse where he was serving as the assistant keeper. Over the next few years, they were stationed at a number of Maine lighthouses before being transferred to Egg Rock Lighthouse. In 1935, Clinton left the Egg Rock Lighthouse for a brief trip to the mainland. He never arrived. Later head keeper Jaurel B. Pinkham found Clinton's capsized skiff about a mile and half from the lighthouse. It was over a month before Clinton's body was finally found. His third child was born about three weeks after his death. (Courtesy Lighthouse Digest and Franklin Dalzell.)

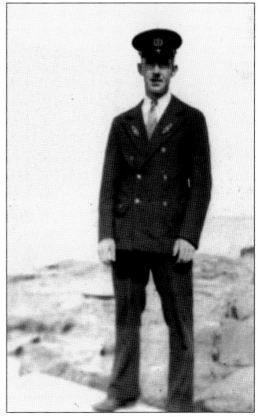

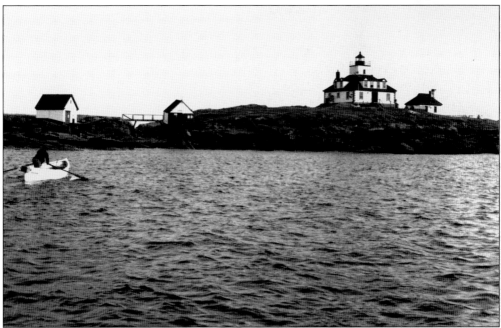

Egg Rock Lighthouse assistant keeper Dalzell was in a small skiff like this when he disappeared in the waters off the lighthouse on his way to the mainland. (Courtesy U.S. Coast Guard.)

Egg Rock Lighthouse keeper Jaurel Benjamin Pinkham became the head lighthouse keeper at Egg Rock Lighthouse on November 21, 1921, and served until he applied for disability retirement on January 1, 1942. He had previously served as a lighthouse keeper at Ram Island Ledge Lighthouse in Casco Bay and Seguin Island Lighthouse at the mouth of the Kennebec River. Two of his mother's brothers, Clarence E. Marr and Wolcott H. Marr, were also lighthouse keepers. He is wearing the white summer dress hat of the Lighthouse Service. The four bars on his sleeve indicate he had been in the service for 40 years. Pinkham was born on September 3, 1881, and died on December 16, 1953. (Courtesy Mary P. Smith.)

Wesley Dalzell, son of assistant lighthouse keeper Clinton Dalzell, is playing on one of the cannons left over from the coastal defense battery that was once on the island at Egg Rock Lighthouse. Wesley, who died in 1953, was three years old when his father died in the waters off the lighthouse. (Courtesy Franklin Dalzell.)

In 1934, Wesley and Franklin Dalzell, sons of assistant keeper Clinton Dalzell, did not have much room to play at the lighthouse. But they had lots of toys, such as this rocking horse that Franklin spent hours on while rocking back and forth. They had no cares in the world. (Courtesy Franklin Dalzell.)

The Newfoundland dog Babe was brought to Egg Rock Lighthouse in 1934 as a puppy to help the children pass their time on the rocky outpost. Although the pet started out its life on an island lighthouse, it was always scared of the water. (Courtesy Lighthouse Digest.)

Lillian Dalzell tries to calm down her son Franklin. Apparently the youngster had no intention of wanting his meal or wanting to sit in the high chair. In many ways, lighthouse life at a remote place like Egg Rock Lighthouse was no different than on the mainland. (Courtesy Franklin Dalzell.)

Wesley Dalzell is all dressed up and getting ready to leave Egg Rock Lighthouse for the last time shortly after the tragic death of his father, assistant keeper Clinton "Buster" Dalzell. His wife, Elizabeth, never remarried, saying no one could ever replace her husband. She raised her three children on the small survivor's pension supplied by the Lighthouse Service. (Courtesy Franklin Dalzell.)

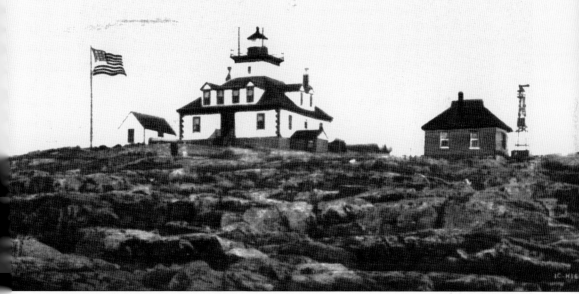

164—Egg Rock Light, Bar Harbor, Maine

In an effort to make the sound of the foghorn heard farther out to sea, the foghorn trumpet was removed from the roof of the fog signal building and placed atop a tower. Since many of the tour boats out of Bar Harbor passed the lighthouse, this was one of the most popular lighthouse postcards of its time. (Courtesy Lighthouse Digest.)

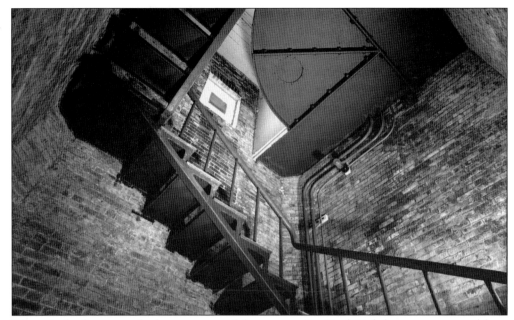

The stairs leading up to the lantern room of the tower at Egg Rock Lighthouse are accessed from the middle of the keeper's house. This is quite different from the spiraling stairs envisioned by many and seen in round lighthouse towers that are not part of the keeper's house. (Courtesy Library of Congress.)

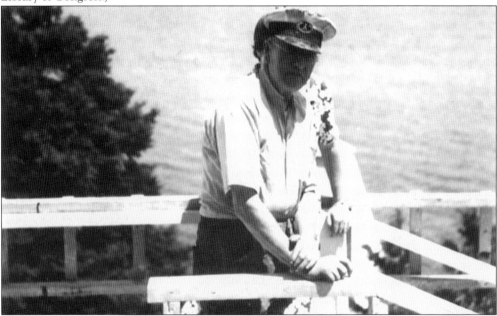

Augustus B. Hamor served at Egg Rock Lighthouse from approximately 1913 to 1930. He is most famously known for his time at Maine's Owls Head Lighthouse, where his dog Spot would ring the fog bell. During one blizzard, the dog was unable to get to the bell. The creature's consistent barking was heard by the captain of a mail boat, who immediately changed course, thus averting disaster. A headstone at Owls Head Lighthouse marks the grave of the famous dog. (Courtesy Bill Geilfuss.)

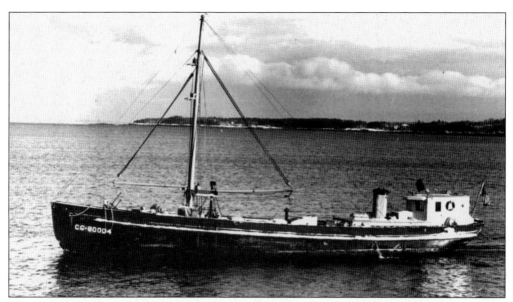

The U.S. Coast Guard lighthouse tender CG-80004 was used for supplying lighthouses along the coast of Maine. Thomas L. Keene, who was captain of the vessel, was a prolific writer and literally wrote hundreds of poems, mostly about lighthouses and life on the high seas. Many of his poems were published in the U.S. Coast Guard magazine. Interestingly, in the mid-1940s, he also served as a keeper at Egg Rock Lighthouse. (Courtesy Robert J. Lewis.)

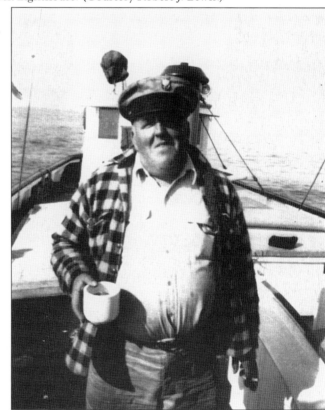

Thomas L. Keene is on board the U.S. Coast Guard lighthouse tender CG-80004; at the time, the mid-1940s, he was captain of the vessel. As well as serving as a U.S. Coast Guard keeper at Egg Rock Lighthouse, he served at West Quoddy and Great Duck Island lighthouses and at the Cross Island Life Boat Station. He also served as the lighthouse keeper at Ten Pound Island Lighthouse in Massachusetts. (Courtesy Julie Keene.)

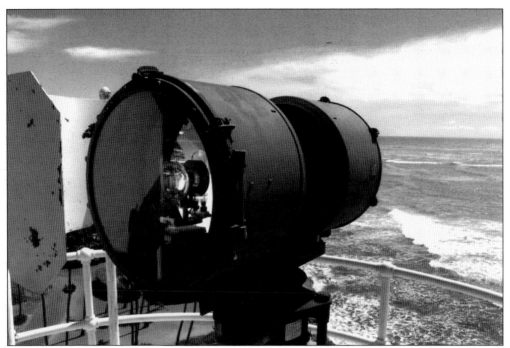

When the U.S. Coast Guard automated Egg Rock Lighthouse, it took the lantern room off the tower and installed rotating aero-beacons. The removal of the lantern room so dramatically changed the appearance of the lighthouse that it was called the ugliest lighthouse in Maine. The U.S. Coast Guard received so many complaints that in 1986 it installed a new aluminum lantern room that now houses a modern optic. (Courtesy Ron Foster.)

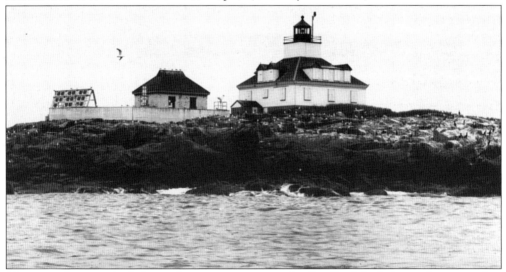

Many tour boats and whale-watching excursions pass by Egg Rock Lighthouse; however, they will no longer see the American flag waving proudly from the flagpole. In fact, the flagpole no longer stands. In 1998, ownership of the lighthouse was transferred to the U.S. Fish and Wildlife Service, and the boarded lighthouse is under the care of the Maine Coastal Islands National Wildlife Refuge, which has no intention of restoring the structure or opening it up to the public. (Courtesy Lighthouse Digest.)

Six

GREAT DUCK
ISLAND LIGHTHOUSE

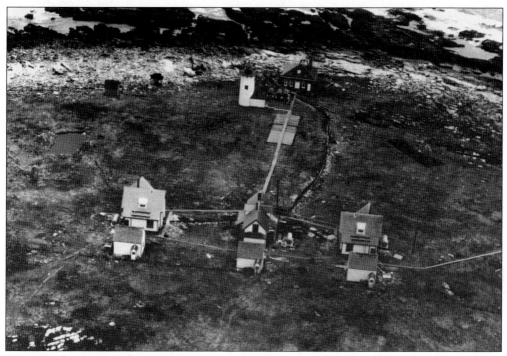

Great Duck Island Lighthouse Station was established in 1890 on 11 acres of the 165-acre Great Duck Island at the approach to Blue Hill Bay and Mount Desert Island near the town of Frenchboro. The island was originally named because of the large pond that was in the middle of the island where thousands of ducks went to hatch their young every spring. Because of the number of shipwrecks in the area, the station at Great Duck Island was a large and important station with a head keeper's house and two assistant keepers' homes. The lighthouse station also had a steam-powered foghorn and 1,200-pound fog bell. (Courtesy U.S. Coast Guard.)

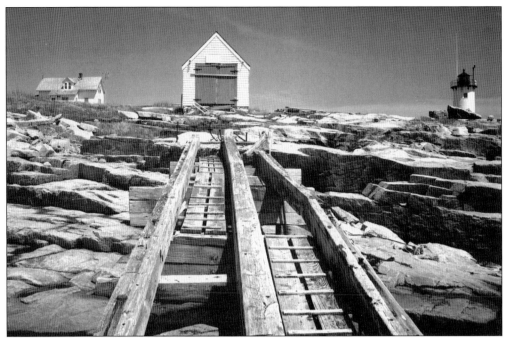

Because of the varied winds, Great Duck Island Lighthouse was the only Maine lighthouse station with two boathouses, one on each side of the island. The small boathouse was primarily used for the small dory assigned to the lighthouse. Nearly all supplies were landed by the large boathouse and then transported by wheelbarrow to the keepers' homes on the other side of the island. (Courtesy Library of Congress.)

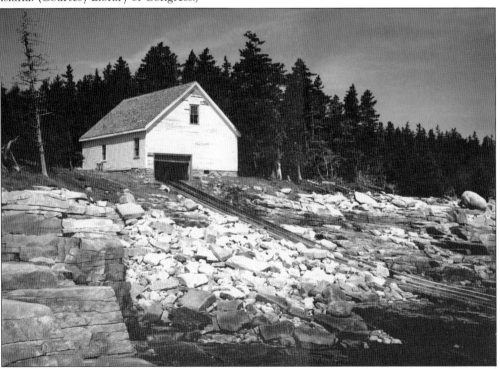

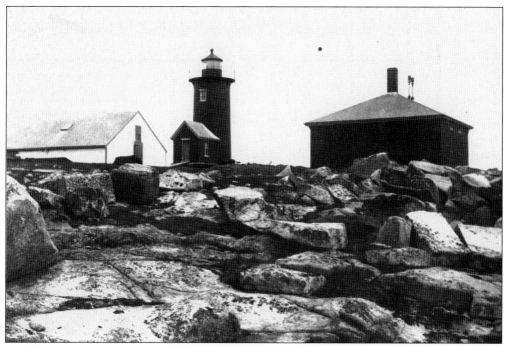

For a period of time, the tower at Great Duck Island was painted a dark brown, probably so it would stand out as a daymark in snowstorms. However, for most of its life, the tower was painted white. The brick building held the machinery for the steam-driven foghorn, and the long white building was probably some type of storage building. (Courtesy Lighthouse Digest.)

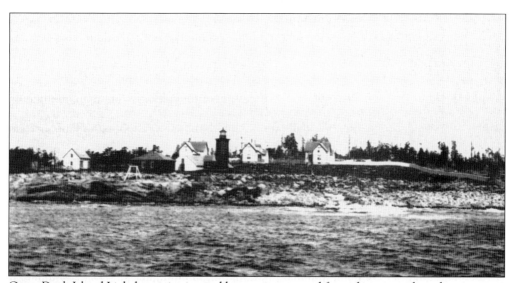

Great Duck Island Lighthouse is pictured here as it appeared from the water when the tower was painted brown. (Courtesy National Archives.)

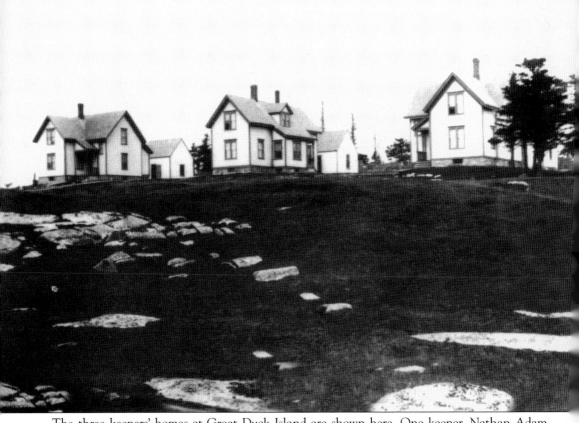

The three keepers' homes at Great Duck Island are shown here. One keeper, Nathan Adam Reed, and his wife, Emma, had 16 children, which resulted in the building of a schoolhouse on the island. They were a close family that played and worked together. Keeper Reed would often play the organ that was brought out to the station, and the girls would sing songs. (Courtesy National Archives.)

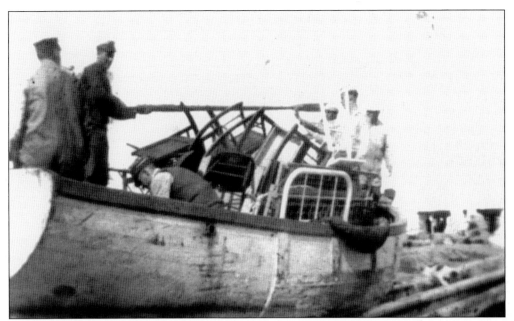

Moving a family's belongings to Great Duck Island Lighthouse were never an easy task, as is evident in this 1920s photograph. The weather had to be just right for the vessel to get to the island. This was generally done on the other side of the island by the larger boathouse. Once the belongings were removed from the boat, they had to be carried to the other side of the island. (Courtesy Alberta Willey.)

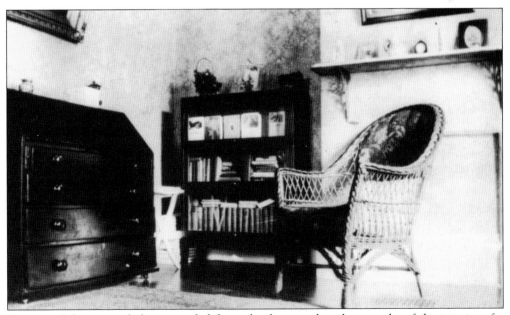

Because of the proper lighting needed for early photography, photographs of the interior of a lighthouse keeper's house are quite rare. This image shows the living room when lighthouse keeper Solomon Howe was stationed at Great Duck Island with his family in the 1920s. (Courtesy Alberta Willey.)

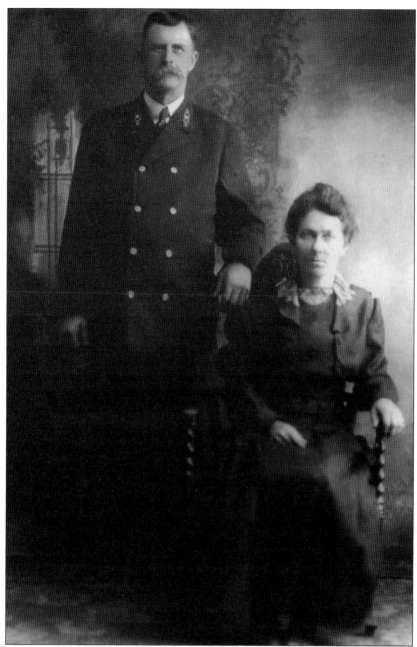

This photograph shows Ephraim Johnson and his wife, Ada, on their 10th wedding anniversary. Johnson was appointed second assistant keeper at Great Duck Island Lighthouse in 1899. He had previously been stationed at Libby Island Lighthouse for 10 years. His granddaughter Gwen Wasson recalled that Johnson was proud of his position as a lighthouse keeper and always wore his keeper's hat, even when he was wearing work clothes. His stay at Great Duck Island Lighthouse was fairly short. In 1901, he was transferred to West Quoddy Head Lighthouse, the easternmost lighthouse on the mainland of the United States. He served there as an assistant keeper under head keeper Warren Much. In 1905, he was promoted to head keeper at West Quoddy Head Lighthouse, a position he held until he retired at age 68 in 1931. (Courtesy Gwen Wasson.)

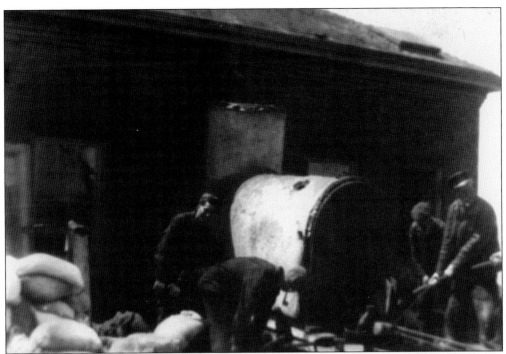

Crewmen from a lighthouse tender struggle as they move a large boiler into the fog signal building at Great Duck Island Lighthouse. They spent an entire two days getting the boiler off the tender, onto a skiff, and up the boat ramp until they got this far to finally move it through the door. It appears they had very little extra room. Photographs of this type of work at a lighthouse are extremely rare. (Courtesy Alberta Willey.)

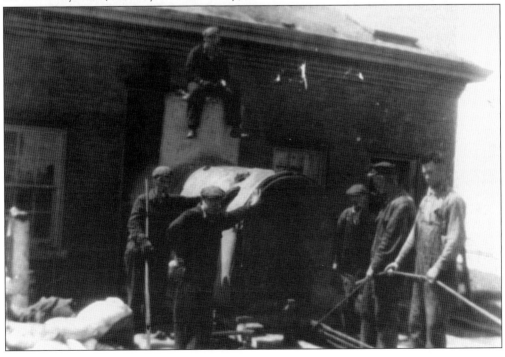

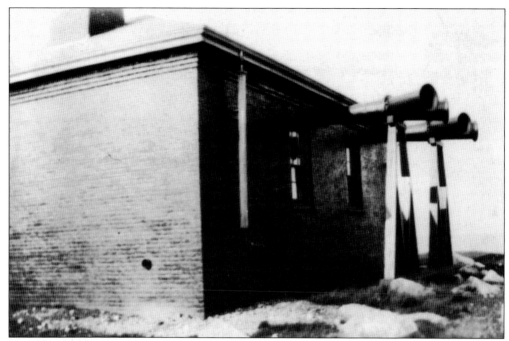

Two new double, steam-powered, air compressor foghorns, as they appeared after installation, protrude out of the fog signal building at Great Duck Island Lighthouse in the 1920s. In later years, when these trumpet-style foghorns were discontinued, they were discarded; however, a few remain in existence. One such example is in the collection of the Maine Lighthouse Museum in Rockland. (Courtesy Alberta Willey.)

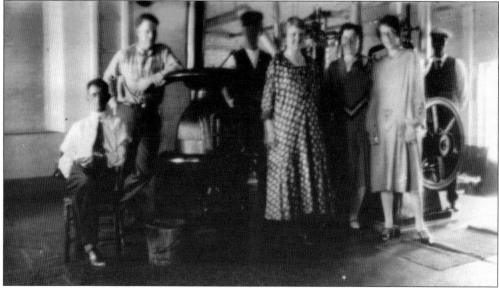

Family members of the lighthouse keepers at Great Duck Island Lighthouse gather around the potbelly stove in the fog signal building in the 1920s. This was a proud moment, as all the backbreaking work of the installation of the heavy equipment was completed, and the system was ready to send out its warning signal to the mariners at sea. The man in the middle is believed to be lighthouse keeper Solomon Howe. (Courtesy Alberta Willey.)

A lighthouse keeper's job was never done, as is evident by this lighthouse keeper having just completed cutting down the high grass from around the keeper's house at Great Duck Island Lighthouse Station. This keeper, with a pipe in his mouth and pitchfork in one hand, was in his work clothes, but as with many keepers, the uniform hat was almost always worn. (Courtesy Alberta Willey.)

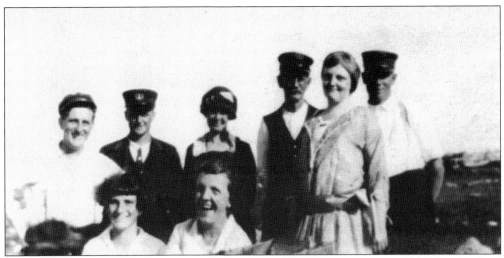

Lighthouse keepers and their families gather for a group photograph at Great Duck Island Lighthouse in the 1920s. This must have been a special celebration of some kind, as they are either laughing or have smiles on their faces. Lighthouse keeper Samuel Howe is the middle keeper in this photograph and his wife, Emily, is on the bottom right. The other keepers and people are unknown. (Courtesy Alberta Willey.)

This vintage advertisement from the New Jersey Zinc Company promoted an unofficial but solid endorsement from the U.S. Lighthouse Board as to why the general consumer should use paint for their homes that contained oxide of zinc. Although the company no longer exists, the highly controversial 1954 movie *Salt of the Earth* was based on the 1950 strike against the New Jersey Zinc Company's Empire Zinc Mine in Baynard, New Mexico. (Courtesy Lighthouse Digest.)

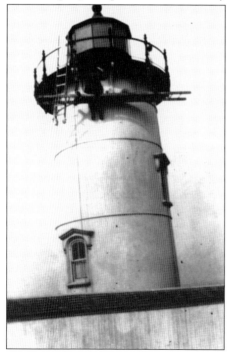

It was the lighthouse keeper's responsibly to paint the tower at Great Duck Island Lighthouse, something that could be quite dangerous when makeshift platforms and wooden rung ladders were used in the 1920s . (Courtesy Alberta Willey.)

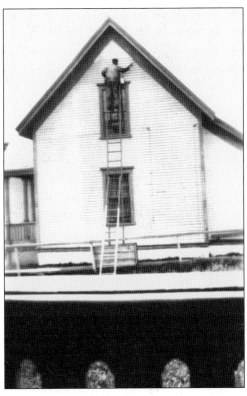

"Fear of heights" are words that were not in the vocabulary of the lighthouse keepers, but steady footing and sometimes nerves of steel were a requirement. A telephone line was installed at the outbreak of World War I, but medical assistance would have taken some time to arrive, probably not for quite some time, especially if the weather was inclement. All lighthouses were provided with quick reference medical manuals, a sort of do-it-yourself book. One of these manuals is now in the collection of the Maine Lighthouse Museum in Rockland. (Courtesy Alberta Willey.)

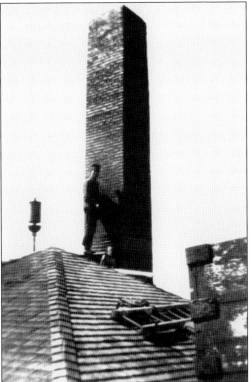

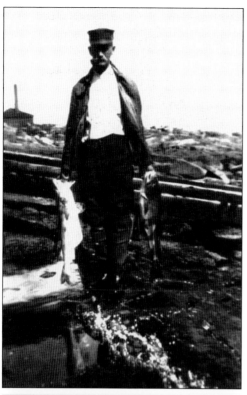

Although fish was a staple of the diet of the lighthouse keepers and their families at Great Duck Island Lighthouse, keeper Solomon Howe still had to catch them before the family could be fed. (Courtesy Alberta Willey.)

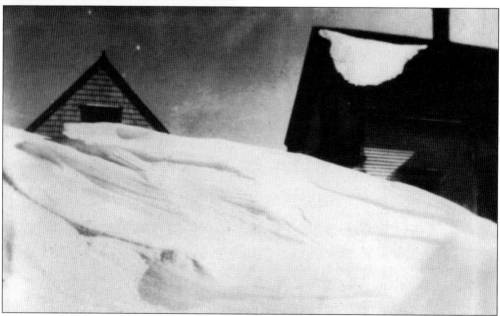

Being so exposed to the fury of Mother Nature presented its challenges to the lighthouse keepers and their families. Drifting snow was not uncommon in the winter months. The great gale of January 27–28, 1933, divided Great Duck Island in half with a lake of water down the middle, which divided the island. The storm washed away an old grave site of shipwrecked sailors that was on the island. (Courtesy Alberta Willey.)

One of the most famous lighthouse keepers in Maine history, Robert Thayer Sterling was stationed at Great Duck Island in the 1930s. His book *Lighthouses of the Maine Coast*, published in 1935, helped document and save much of Maine's lighthouse history, most of which he had gained from firsthand experience and knowledge. Sterling was also the last keeper of the USLHS to serve at Maine's famous Portland Head Lighthouse in Cape Elizabeth, a story that is well documented in the book *Portland Head Light, A Pictorial Journey Though Time*. (Courtesy John Sterling.)

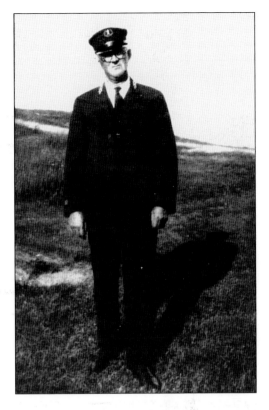

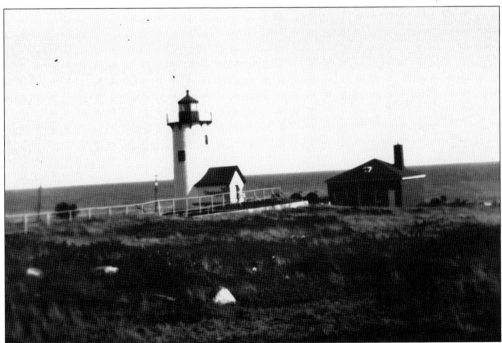

At one time, a wooden walkway with a hand railing led from the keepers' houses to the fog signal building and the tower at Great Duck Island Lighthouse. (Courtesy Lighthouse Digest.)

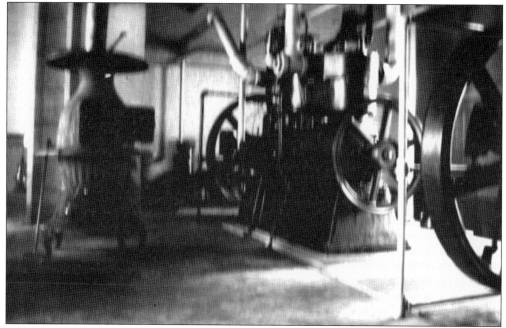

Keeping the elaborate machinery in running order in the fog signal building at Great Duck Island Lighthouse often required more work than any of the other duties of the lighthouse keeper. However, if the keepers ran into major problems, they would call for the district machinist who would make arrangements to get to the lighthouse as soon as possible. (Courtesy Lighthouse Digest.)

As one of the 16 children of lighthouse keeper Nathan Reed, his son Dalton, in a 1978 interview, recalled living on Great Duck Island saying, "My father used to buy twelve to fourteen barrels of flour every fall and this was above and beyond what the government would provide. He also bought crackers and different types of cereal and a lot of molasses. Everything came in barrels and was stored in the basement." He also said the family did not eat much meat but always had plenty of fresh fish and lobster. (Courtesy Homegrown Magazine.)

Veteran lighthouse keeper James H. Freeman was stationed at Petit Manan Lighthouse for 12 years. His son Robert is on his lap during family time in 1932. In 1939, when the U.S. Coast Guard took over, he was transferred to Great Duck Island Lighthouse. Many years later, Freeman's daughter, Maizie, wrote, "Soon after our arrival in 1939, the Coast Guard took over the running of the lighthouses and the old lighthouse keepers were gradually replaced by Coast Guardsmen. My father was one of those replaced." (Courtesy Lighthouse Digest.)

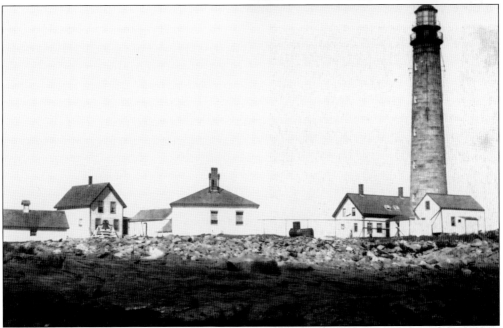

James H. Freeman served as the lighthouse keeper at Petit Manan Lighthouse for 12 years before being transferred to Great Duck Island Lighthouse. The 1854 Petit Manan Lighthouse, at 119 feet high, is the second-tallest lighthouse in Maine. It is now part of the Maine Coastal Islands National Wildlife Refuge. (Courtesy U.S. Coast Guard.)

Catherine and Maizie Freeman, daughters of lighthouse keeper James H. Freeman, are photographed in 1934. Maizie was born at Petit Manan Lighthouse. Both girls loved island lighthouse life. (Courtesy Catherine Freeman Thaxter.)

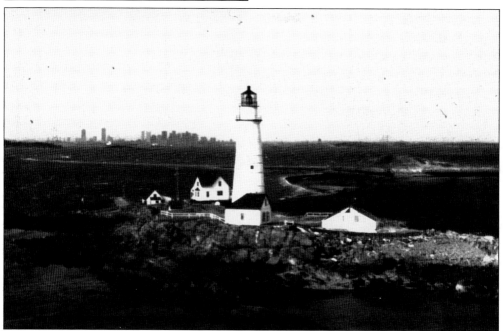

In 1947, Maizie married a U.S. Coast Guardsman who later became a lighthouse keeper at Boston Lighthouse in Massachusetts, which was the site of America's first lighthouse. Interestingly, Maizie's fourth child was born while she was living at Boston Lighthouse. (Courtesy Lighthouse Digest.)

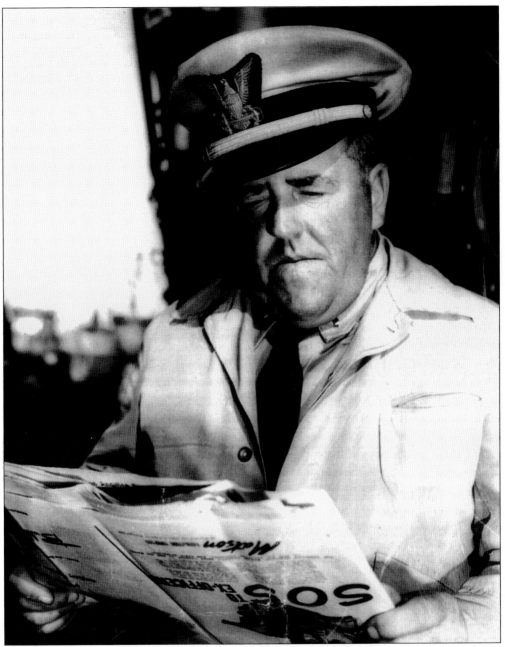

In the late 1940s, Thomas L. Keene was stationed at Great Duck Island Lighthouse. Although it was on an island, it was still a family lighthouse station and his family lived there with him. Years later, his son Bruce recalled how much he loved living on the island, although he remembered it was also rough at times. He recalled that someone had released rabbits on the island and they had multiplied and were everywhere. "I had fun hunting," he said, "which also provided us with fresh meat. We also hand-lined and caught fresh fish and we had our own lobster traps. We ate very well." In recalling the Great Bar Harbor Fire, he said, "We had a bird's eye view of the fire . . . from the end of the point we watched the fire go up over Cadillac Mountain in one sweep." (Courtesy Julie Keene.)

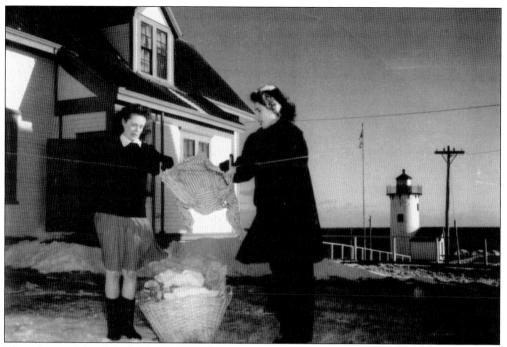

This photograph of the keepers' wives, hanging out the clothes to dry at the windswept Great Duck Island Lighthouse, was widely distributed by the U.S. Coast Guard to the media. However, the era of lighthouse keeping at Great Duck Island Lighthouse was soon about to end. (Courtesy U.S. Coast Guard.)

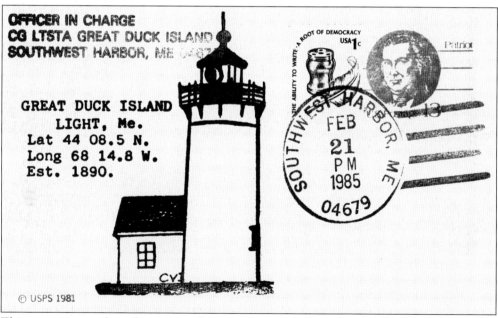

This souvenir envelope from the officer in charge at Great Duck Island Lighthouse was postmarked just months before the station was automated and lighthouse keepers left the island for the last time. (Courtesy Lighthouse Digest.)

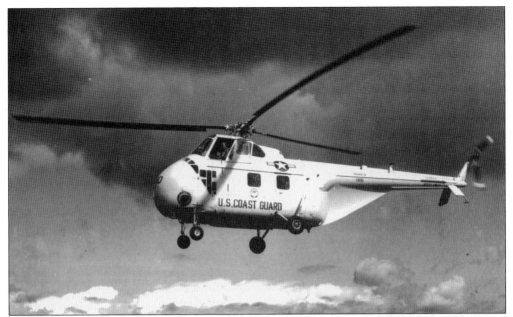

After Great Duck Island Lighthouse and other lighthouses were automated, the U.S. Coast Guard used helicopters, which allowed it to quickly and easily service the lighthouses that were now automated and void of human life. (Courtesy Lighthouse Digest.)

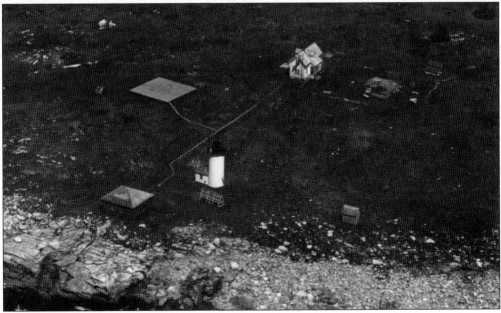

When Great Duck Island Lighthouse was automated, the U.S. Coast Guard destroyed two of the keeper's homes and left only one of them standing. The new helicopter pad was called "part of the modernization." In 1998, Great Duck Island Lighthouse and a few acres around it became the property of Bar Harbor's College of the Atlantic, to be used for programs that study ecology and botany. The Maine Chapter of the Nature Conservancy owns most of the rest of the island. It is estimated that the island supports 20 percent of Maine's nesting seabirds. (Courtesy Lighthouse Digest.)

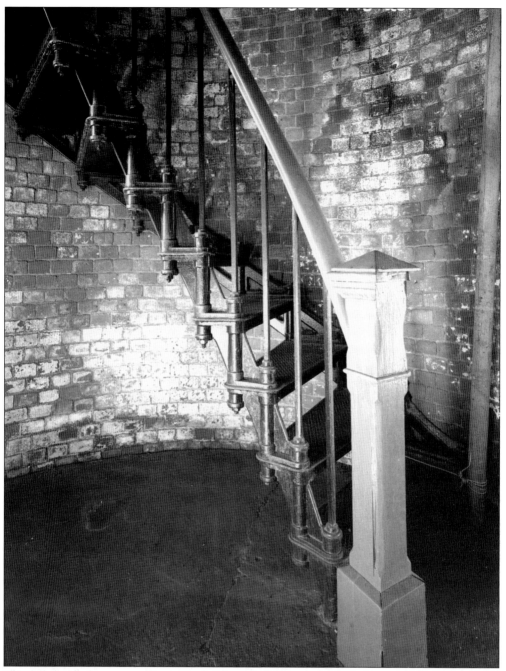

The lighthouse keepers at Great Duck Island Lighthouse climbed these spiraling stairs on a daily basis to maintain the beacon. Today the sound of footsteps in the tower is rarely heard. (Courtesy Library of Congress.)

Seven

MOUNT DESERT ROCK LIGHTHOUSE

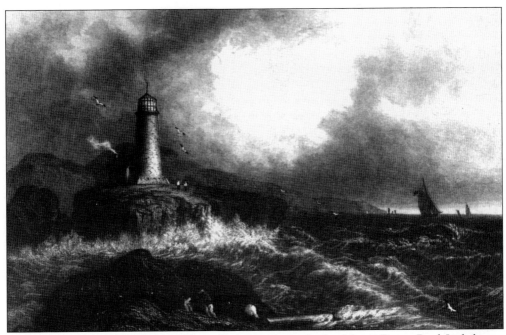

Sitting on a rock 20 miles out to sea from the nearest port, the first Mount Desert Rock Lighthouse went into operation in the late summer of 1829. Although this artist's rendition is not correct, it is accurate in the fact that the first tower was attached to a stone keeper's house. In spite of waves and storms that often pounded the island, the structure lasted until 1847. (Courtesy National Archives.)

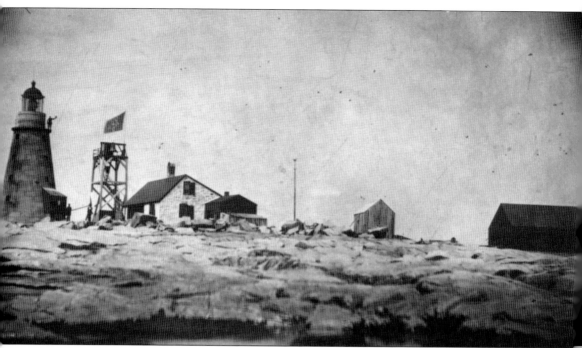

The second Mount Desert Rock Lighthouse, designed by prominent architect Alexander Parris, was completed in 1847. The small enclosed wooden entryway attached to the tower did not last long; it was destroyed in a storm. After complaints from mariners, a fog bell was added to the station and mounted on this crudely built bell tower. The stone keeper's house, still standing when this photograph was taken, was originally attached to the first lighthouse tower at the site. Sometime later, the original stone lighthouse keeper's house was demolished and replaced by another structure. (Courtesy National Archives.)

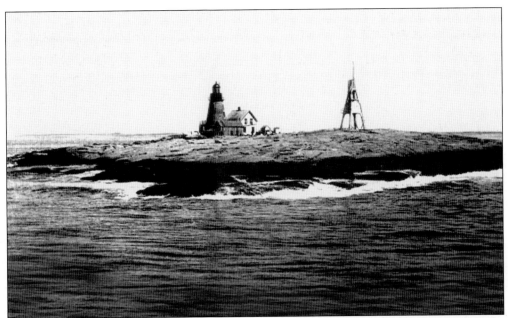

Sitting only 17 feet above sea level at its highest point, many officials considered Mount Desert Rock Lighthouse as the most exposed lighthouse in the United States, a fact that was disputed by lighthouse keepers who were stationed at other exposed sites. Designed to withstand storms, the base of the tower is four feet thick all the way around. Over the years, the lighthouse had a number of different bell towers, most of which were destroyed in storms. (Courtesy Lighthouse Digest.)

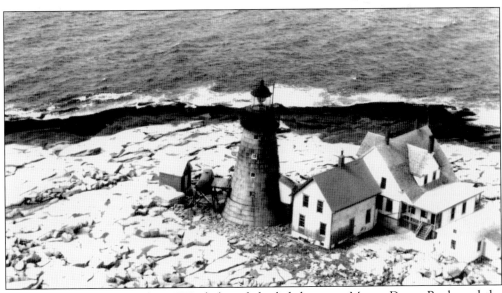

An early winter storm, in late 1878, darkened the lighthouse at Mount Desert Rock, and the locals thought the lighthouse had been washed away. Over the years, all the keepers that were stationed here experienced violent storms. Lighthouse keeper George York, recalling a storm in 1933, said, "The water came under the door of the house. About three hours before high tide I called the assistants and their families and told them to get food and water and get into the tower as soon as possible." (Courtesy Lighthouse Digest.)

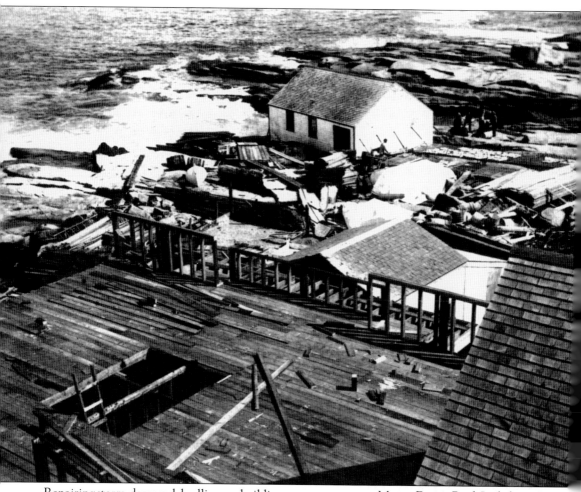

Repairing storm-damaged dwellings or building a new structure at Mount Desert Rock Lighthouse was no easy task—certainly beyond the capabilities of the three lighthouse keepers assigned to the lighthouse. Specialists, such as carpenters and masons, arrived on a lighthouse tender, which was also loaded with the supplies necessary to accomplish the work. Oftentimes work was delayed as rough seas made the landing of supplies too dangerous to attempt. (Courtesy Lighthouse Digest.)

Because of weather conditions, veteran assistant lighthouse keeper Capt. William Dodge, while serving at Mount Desert Rock Lighthouse in the early 1920s, often ran short on supplies and oil to light the lamps. Oftentimes the supply ship was weeks late or in some cases sat in the waters off the lighthouse waiting for weather conditions to improve before a smaller boat could be launched. (Courtesy Lighthouse Digest.)

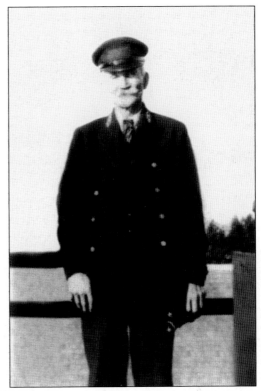

From the only known portrait of Charles W. Thurston, it appears he was a young man when he was promoted from second assistant keeper to first assistant keeper at Mount Desert Rock Lighthouse in 1897. He later served at Saddleback Ledge Lighthouse. He died while on duty in 1909. (Courtesy Molly Melrose.)

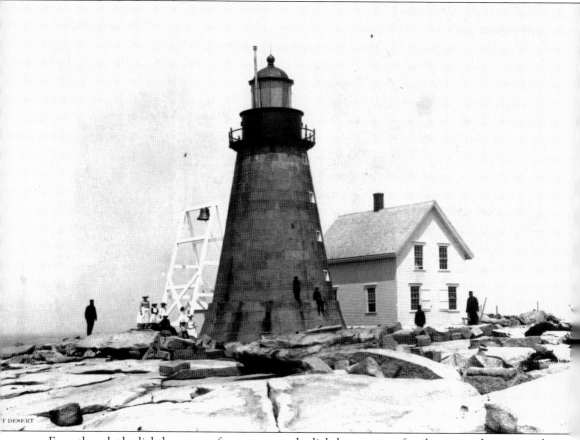

Even though the lighthouse was far out to sea, the lighthouse was a family station that required several keepers who lived there with their wives and children. Even at a remote lighthouse such as Mount Desert Rock, the women wore long dresses, and on Sundays, everyone always dressed up. The bottom windows of the keeper's house had strong wooden shutters that would be closed in storms to prevent rocks from breaking the glass. One lighthouse family hired a teacher from the mainland who would come out to the lighthouse for 10 days at a time to help tutor the children with their schoolwork. Throughout the existence of the lighthouse, there were several opened-framed fog bell towers used at the site; one of them held a 1,500-pound bell. The curtains in the lantern room were drawn to protect the valuable Fresnel lens from the harmful rays of the sun. (Courtesy U.S. Coast Guard.)

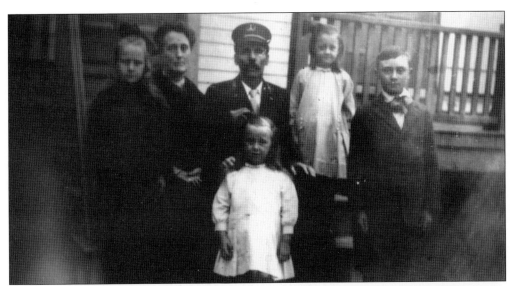

Lighthouse keeper Vinal Beal is seen here with his family; daughter Velora and wife Nettie are to his left, Robina is in the front, and to the right of Vinal are children Virginia and Harvard. When Robina, the youngest, would play outside, a rope was attached around her waist with the other end looped around a clothesline, which extended from the house, ensuring that she could not wander and possibly be washed off the rock they lived on. Vinal served at Mount Desert Rock Lighthouse from 1909 to 1918 when he was transferred to Franklin Island Lighthouse. (Courtesy Vicki Salsbury.)

Inez and Arthur Ginn served at Mount Desert Rock Lighthouse in the early 1900s. When they decided their children Alice and Ethelyn were falling behind in their schoolwork, they hired a lady on the mainland where the children could be boarded so they could attend a real school. On the weekends, weather permitting, the children would return to the island. One year, they brought a load of dirt out to the island so a garden could be planted. They never saw the results of their work. The wind and the water took the dirt out to sea before anything could grow. (Courtesy Suzanne Clark.)

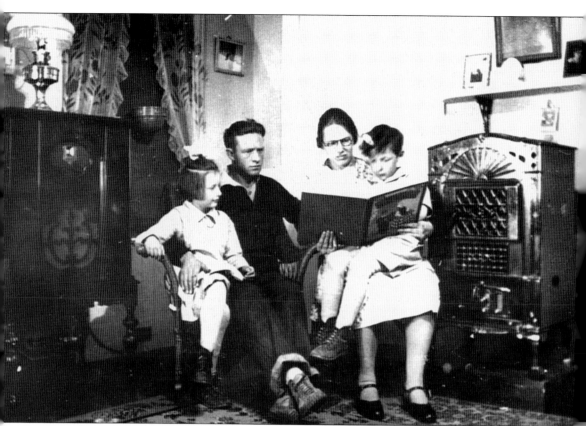

Family reading time in the living room at Mount Desert Rock Lighthouse, with lighthouse keeper George York and daughter Shirley (to his left), wife Helen, and son Wilbur (Bill), was done nearly every night by the York family. The enamel stove to the right was used for heating, and the old radio to the left was their entertainment center and the only real contact to the outside world. George was stationed at Mount Desert Rock Lighthouse from 1928 to 1936. When interviewed in later years, George said, "When we lived out there, I didn't want to come ashore. The 'Rock' was my home. I never had time to get lonesome. In the summer, the days were not long enough." In talking about automation he said, "To me, if there are no lighthouse keepers there is no Lighthouse Service. It's like a ship without a captain, a hospital without a nurse; you can do, but what are the results? Those old sea captains on those old schooners would agree with me, but there are none of them left." (Courtesy Shirley York Robinson.)

Everett W. Quinn, George York, and Henly Day were three of the lighthouse keepers stationed at Mount Desert Rock Lighthouse in the 1930s. It is obvious, even to the casual eye, by the way these men are standing that they are proud of the duty they provided as the keepers of the light. Quinn was the last official lighthouse keeper to serve at St. Croix River Lighthouse that once stood on an island near Calais. (Courtesy Shirley York Robinson.)

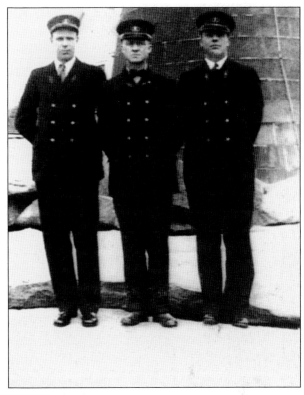

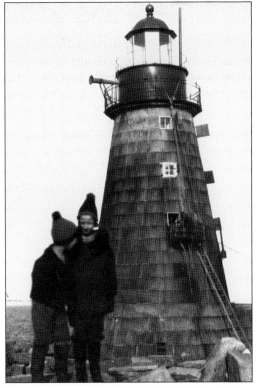

While the children of lighthouse keeper George stand a good distance from the tower, the lighthouse keepers perform maintenance on the tower using a homemade basket as an enclosed platform. Perhaps six-year-old Bill was telling Shirley, age eight, that he wanted to climb the ladder and help. Many years later, Shirley was the driving force behind having a replica of Mount Desert Rock Lighthouse built at Lake Havasu, Arizona, a long way from the remote lighthouse home where she grew up. (Courtesy Shirley York Robinson.)

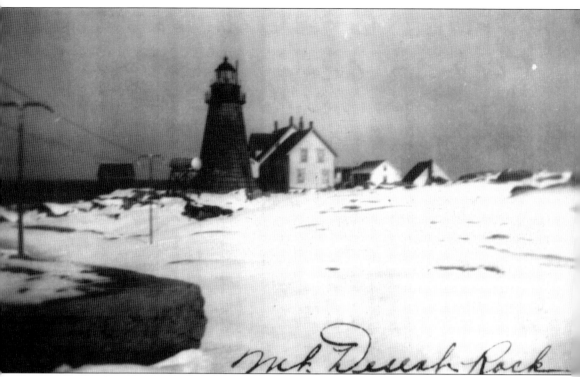

During a blinding snowstorm, crew members of the ocean tug *Astrail* were unable to see the beam from Mount Desert Rock Lighthouse, but they did hear the sound of the fog bell. However, they did not hear it in time, and the ship struck the hidden rocks near the lighthouse. As the vessel began to break apart, the ship's captain kept blowing the vessel's steam whistle, signaling for help, which was heard by the lighthouse keepers. As the cold ocean waves splashed over them in the howling gale, the lighthouse keepers threw out a line to the ship. Slowly, one by one, they rescued 17 of the 18 crew members. The survivors remained with the lighthouse keepers for six days before help could arrive to get the men to a hospital, where one of them remained a full year before recovering. (Courtesy Flavilla Gray.)

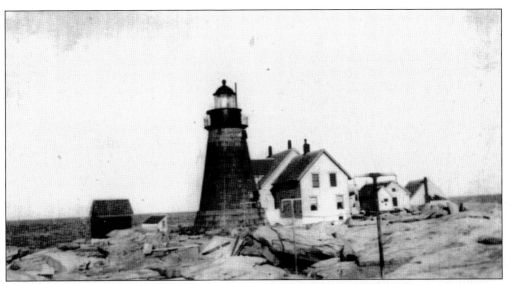

Since it was nearly unheard of to have film development material and equipment at a lighthouse, this may be one of the most collectible lighthouse photographs in history. It was taken in 1929 by lighthouse keeper George York, who personally developed it in the darkness of the tower at Mount Desert Rock Lighthouse. (Courtesy Shirley York Robinson.)

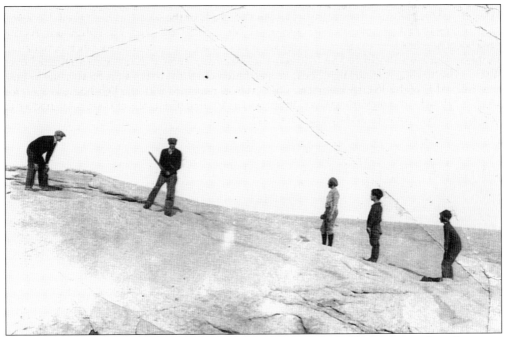

It is doubtful that very many baseball games in history have been played on a rock in the ocean surrounded by water. However, with no soil on Mount Desert Rock, the keepers and their families had no choice. Pitching uphill must have been quite a challenge, and hitting a home run meant the ball could be lost forever, thus ending the game. (Courtesy Shirley York Robinson.)

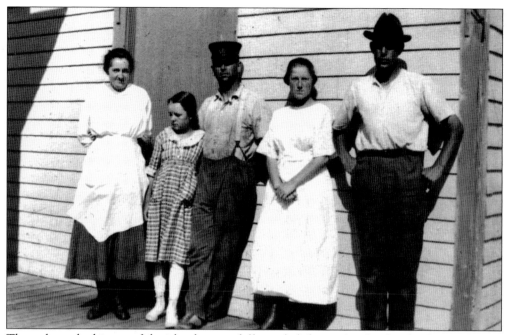

Throughout the history of the island, many different lighthouse families lived at Mount Desert Rock Lighthouse. Unfortunately, members of this group did not write their names on the photograph. (Courtesy Lighthouse Digest.)

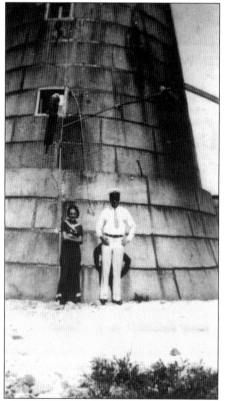

Seen here is lighthouse keeper Everett Quinn with Flavilla Lamb, a relative of the first assistant keeper, in August 1937, at Mount Desert Rock Lighthouse. Quinn's white hat, shirt, and slacks were called "summer whites." Although some Maine lighthouse keepers wore them, they were more prevalent with lighthouse keepers in states with warmer climates. Recalling a major storm at the lighthouse a number of years earlier, when the keepers and their families took refuge in the tower, Lamb wrote a poem about the experience. One part of that poem reads, "The men kept watch all night, And just at the break of dawn, We looked from the tower window, And found one building gone." (Courtesy Flavilla Lamb Gray.)

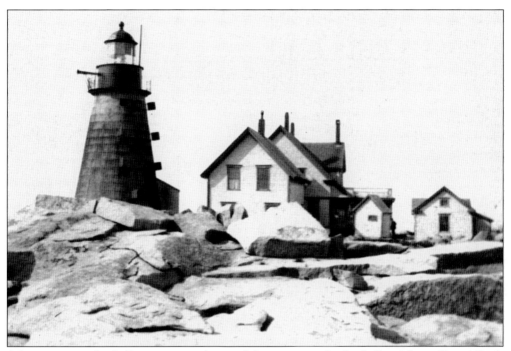

After numerous fog bell towers were damaged from storms, the fog bell at Mount Desert Rock Lighthouse was replaced by a foghorn trumpet that was eventually mounted near the top of the lighthouse tower. The storm shutters on the tower were kept open in good weather to allow the moisture in the tower to dry. (Courtesy Lighthouse Digest.)

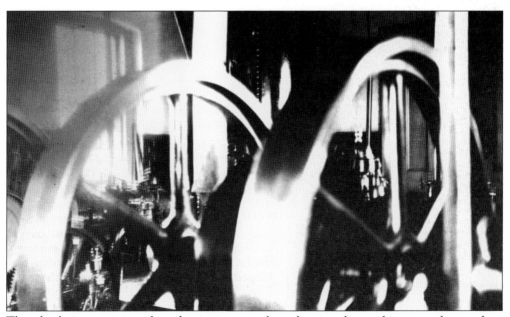

The wheels were turning when this image was taken, showing the machinery used to produce the steam for the foghorn that was mounted at the top of the tower at Mount Desert Rock Lighthouse. (Courtesy National Archives.)

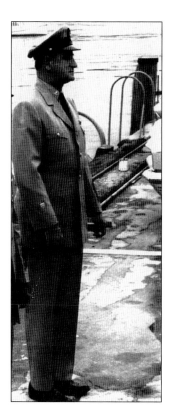

Chief Boatswain's Mate Russell Reilly, U.S. Coast Guard, had a long and distinguished career. As well as serving as a U.S. Coast Guard lighthouse keeper at Mount Desert Rock Lighthouse, he served at Little River, West Quoddy, and Whitlocks Mill lighthouses. He was one of the few lighthouse keepers to also have the distinction of serving on a lightship, which was considered by many as the most dangerous of all assignments in the U.S. Coast Guard. (Courtesy Kelly Reilly.)

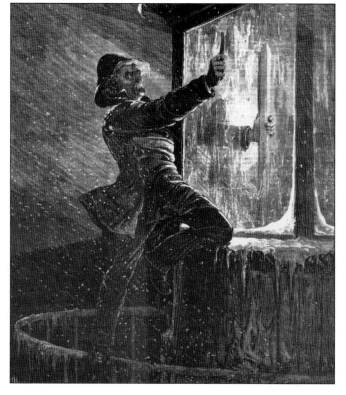

The December 30, 1876, edition of *Harper's Weekly* provided an excellent glimpse into the dangers a lighthouse keeper faced while keeping the ice from the windows of the lantern room during a blizzard. One false move and the lighthouse keeper could suffer serious injury or even death. (Courtesy Lighthouse Digest.)

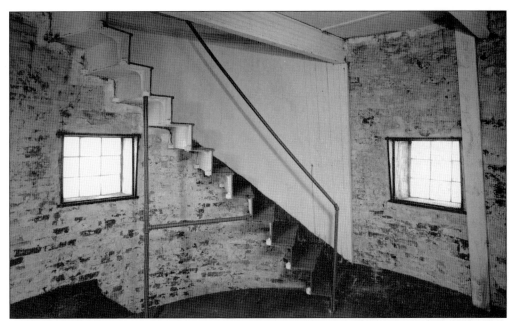

The second-floor interior of the tower at Mount Desert Rock Lighthouse is seen as it appeared toward the end of the era of being a manned U.S. Coast Guard station. This is where lighthouse keepers and their families would have slept while taking refuge during storms as waves would rush over the island. (Courtesy Library of Congress.)

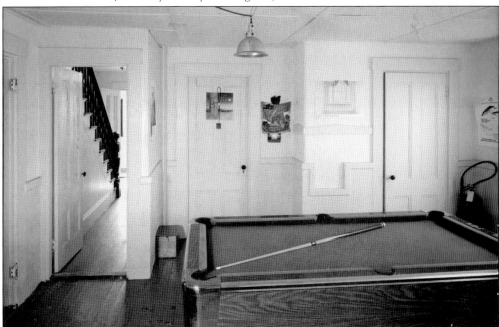

Toward the end of the U.S. Coast Guard era at Mount Desert Rock Lighthouse, the lighthouse became a stag station and wives or family members were not allowed to live there. Where the keepers of yesteryear may have had their living room furniture was now used as a recreation room, complete with a pool table. The sound of family life was gone forever. (Courtesy Library of Congress.)

This photograph shows the outside stairs leading to the entryway of the tower at Mount Desert Rock Lighthouse. Barely visible are the worn numbers 1847, indicating the year the magnificent tower was completed. (Courtesy Library of Congress.)

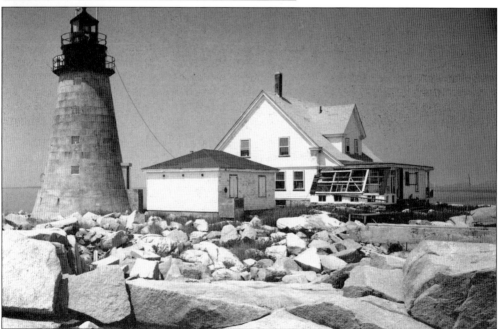

Mount Desert Rock Lighthouse was automated in 1977, and its keepers were removed. The lighthouse was then licensed to the College of the Atlantic as a whale-monitoring station. In 1998, under the Maine Lights Program, the college received ownership of the island and lighthouse. It is now off-limits to the general public. (Courtesy Library of Congress.)

Eight

PROSPECT HARBOR LIGHTHOUSE

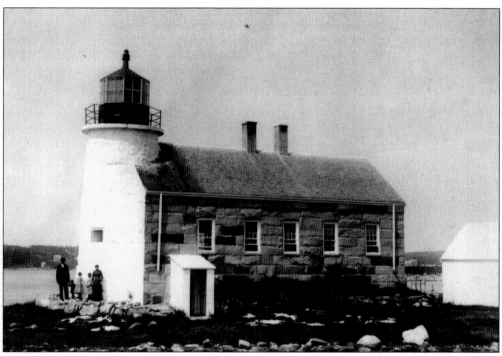

The first Prospect Harbor Lighthouse was established in 1850 to mark the east side of the harbor entrance for the fishing trade of the area. The tower was attached to the keeper's house that was built from blocks of granite. However, nine years later, as shipping in the area declined, it was felt the lighthouse was no longer needed. It was then deactivated and turned over to a caretaker. When the coastal fishing in the area again increased, the lighthouse, which had been dark for 11 years, was reactivated in 1870, and a light beamed again from its tower. (Courtesy U.S. Coast Guard.)

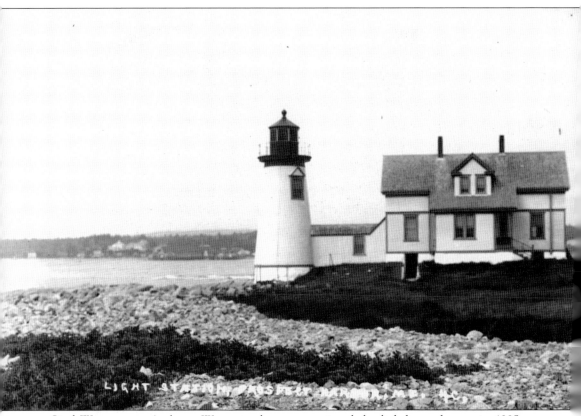

LIGHT STATION PROSPECT HARBOR, ME.

Civil War veteran Ambrose Wasgatt, who was appointed the lighthouse keeper in 1885, was here during the transition from the original structure to the new lighthouse and keeper's house that were built in 1891. The new 38-foot-tall conical wooden tower was attached by an enclosed walkway to the new wooden keeper's house.

Albion T. Faulkingham, a veteran lighthouse keeper of many light stations, served at Prospect Harbor from 1925 until his retirement in 1935. He had previously served at Whitehead, Moose Peak, Libby Island, Matinicus Rock, Owls Head, Monhegan, and Baker Island lighthouses. During most of his time as a lighthouse keeper, his wife, Lucy, and daughters Marcha, Florence, and Beatrice "Dee Dee" lived with him. The children all had fond memories of lighthouse life. At the time of his retirement, Prospect Harbor Lighthouse was automated, and the fog bell at the lighthouse was replaced by a bell buoy in the harbor. The local newspaper reported that Faulkingham was a popular keeper and was well liked by the people in the community. (Courtesy Vicki Tuthill.)

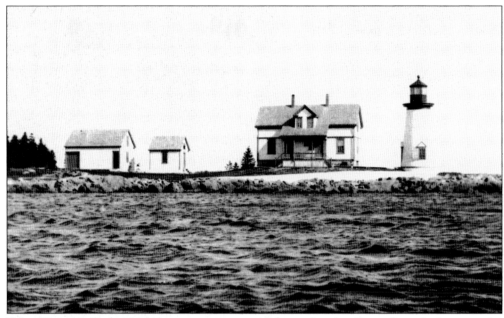

When Prospect Harbor Lighthouse was automated the enclosed walkway from the house to the tower was removed. John Workman was hired by the government to be the caretaker-keeper, a position he held until 1953. The two support buildings, shown to the left, no longer stand. (Courtesy Lighthouse Digest.)

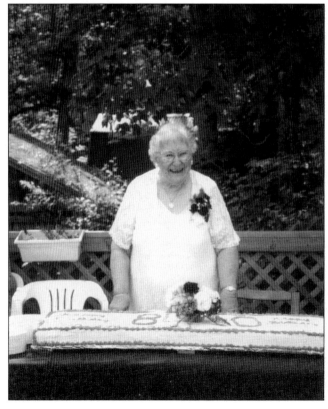

Winifred Reynolds is pictured here at her 80th birthday party in 1997. She was born in the keeper's house at Prospect Harbor Lighthouse in 1917 when her grandfather Ambrose Wasgatt served as the keeper from 1885 to 1924. (Courtesy Lighthouse Digest.)

A stone oil house was added to Prospect Harbor Lighthouse in 1908. It is still standing and still used for storage of flammable materials. (Courtesy Lighthouse Digest.)

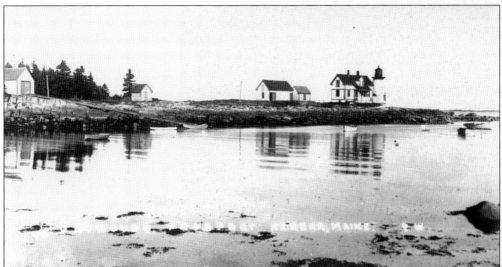

The wife of one of the lighthouse keepers sent this postcard to a relative or friend in Massachusetts. She wrote on the back of the card how much they enjoyed sitting on the rocks by the lighthouse, especially in the moonlight. The boathouse to the far left is still standing but is now used as a guardhouse for the U.S. Navy, which operates a highly sensitive installation at the site. (Courtesy Lighthouse Digest.)

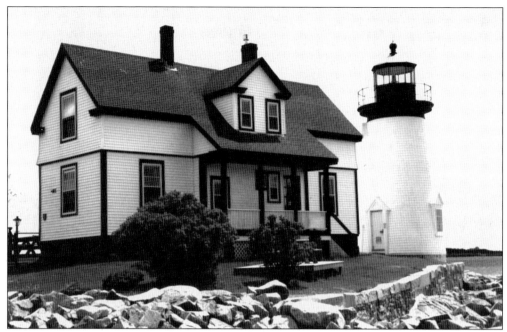

Although the U.S. Coast Guard continues to operate the light from the tower as an aid to navigation, the actual structure is licensed to the American Lighthouse Foundation. However, the keeper's house is owned by the U.S. Navy and is operated as the Gull House, for overnight stays for active and retired military families. (Courtesy Lighthouse Digest.)

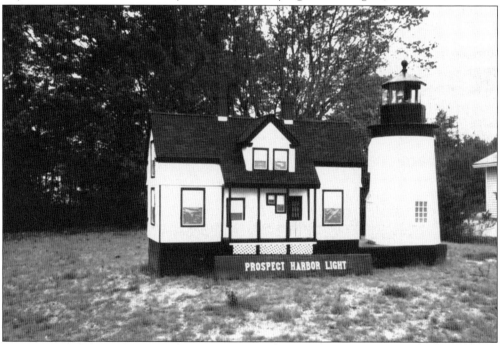

PROSPECT HARBOR LIGHT

This large replica of the Prospect Harbor Lighthouse sits in front of the community house. The replica is popular with tourists, and it is not uncommon to see them photographing it. (Courtesy Lighthouse Digest.)

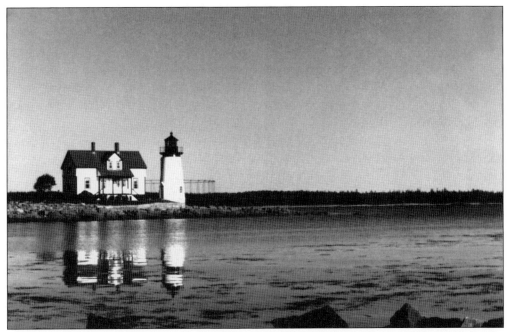

Barely visible in the distance is the Wullenweber, also called the "Dinosaur Cage" by locals, which is a set of concentric receiving rings over 200 feet in height with a total diameter of 1,300 feet. This was the result of a war prize brought back from Germany at the conclusion of World War II. The U.S. Navy purchased 700 acres of land near Corea for the installation. (Courtesy Lighthouse Digest.)

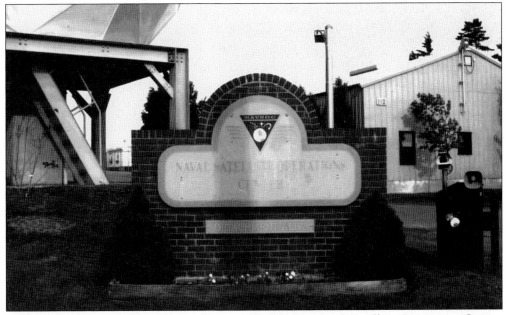

Prospect Harbor Lighthouse is on the grounds of the Naval Satellite Operations Center, a highly secure and well-guarded site. The lighthouse and the grounds are not open to the public, but the lighthouse can be viewed and photographed from nearby locations. (Courtesy Lighthouse Digest.)

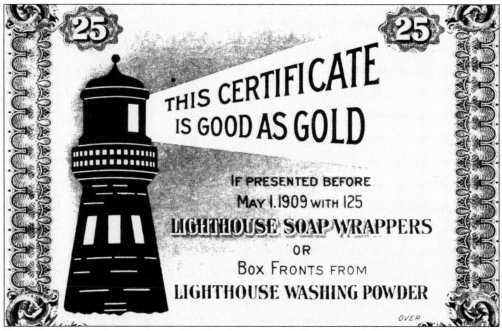

THIS CERTIFICATE IS GOOD AS GOLD

IF PRESENTED BEFORE MAY 1. 1909 WITH 125

LIGHTHOUSE SOAP WRAPPERS

OR

BOX FRONTS FROM

LIGHTHOUSE WASHING POWDER

OVER

From the late 1800s into the mid-1900s, Armour and Company of Chicago, capitalizing on the popularity of lighthouses, manufactured Lighthouse Hand Soap, Lighthouse Cleanser, and Lighthouse Washing Powder. This promotional coupon was handed out at general stores as part of a promotion for these products. When any combination of 150 wrappers, box fronts, or coupons was accumulated, they could be redeemed for a set of six handcrafted teaspoons made by William Rogers and Sons. In modern times, Prospect Harbor Soap Company, also capitalizing on the popularity of lighthouses, uses an image of Prospect Harbor Lighthouse on the labels of its products. (Courtesy Lighthouse Digest.)

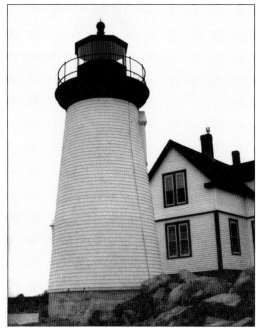

In May 2000, the author of this book, serving at that time in his capacity as president of the American Lighthouse Foundation, secured a license from the U.S. Coast Guard for the nonprofit group to provide historic long-term care of the tower. (Courtesy Lighthouse Digest.)

In the spring of 2004, it was discovered that the wooden platform, dating from 1891, which held the heavy lantern room in place on top of the tower, had rotted through, causing water to leak into the tower, which had also caused damage to the wooden support beams. The tower, which is one of the last remaining wooden conical towers in America, was in danger of collapse from the weight of the lantern room crushing through the rotted platform. In August 2004, the American Lighthouse Foundation, with financial assistance from its Cape Cod chapter from money generated from overnight stays at Race Point Lighthouse in Massachusetts and other donated funds, began the process of saving the tower. (Courtesy American Lighthouse Foundation.)

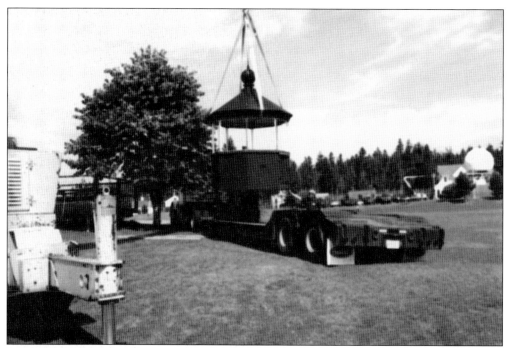

In August 2004, the lantern room and safety railing of Prospect Harbor Lighthouse were removed from the tower and taken away for restoration at an off-site location. During this process, all lead paint was removed. (Courtesy Walter Spear.)

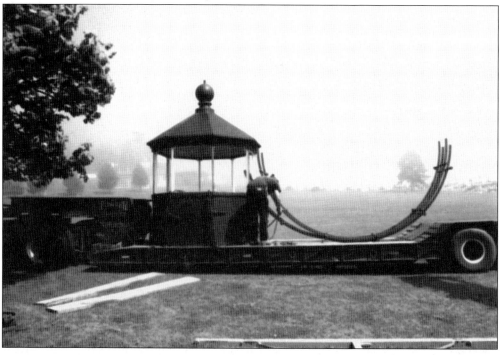

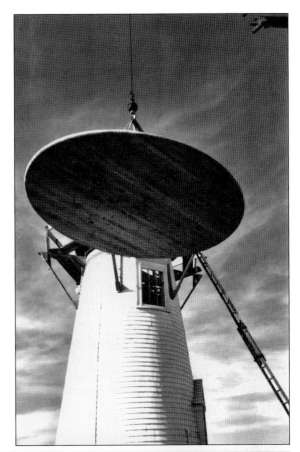

The historically accurate and newly constructed lantern room floor and outer deck, which was made by Spear Mill Works of Machias, is carefully lifted into place atop the tower. The August 2004 restoration only took a few weeks to complete. (Courtesy American Lighthouse Foundation.)

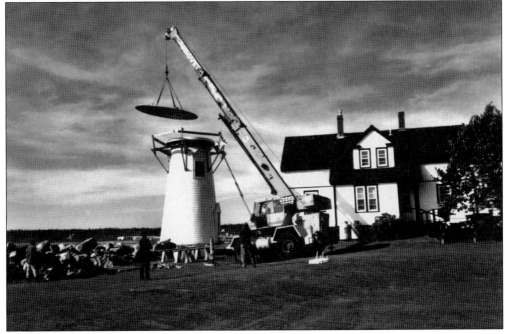

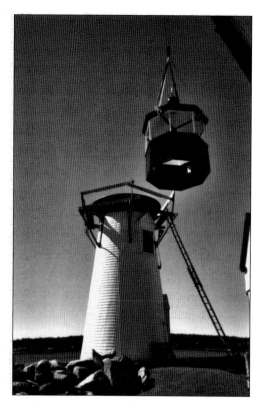

The restored lantern room of Prospect Harbor Lighthouse is carefully hoisted back into place. With no room for error, this required precise placement by the crane operator. A modern optic was installed in the tower, and the lighthouse again sends forth its beam of light. (Courtesy American Lighthouse Foundation.)

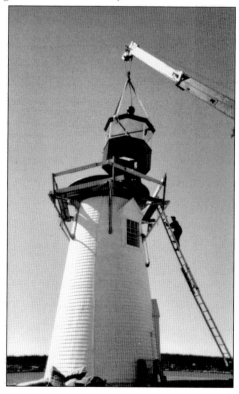

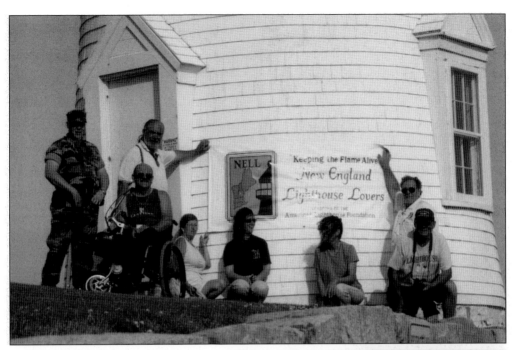

Some of the members of the New England Lighthouse Lovers (NELL), a chapter of the American Lighthouse Foundation, who raised money to fund new windows in the Prospect Harbor Lighthouse tower, visited the site in July 2006. This extremely active group has raised tens of thousands of dollars to assist a number of lighthouse preservation and restoration projects throughout New England. (Courtesy Lighthouse Digest.)

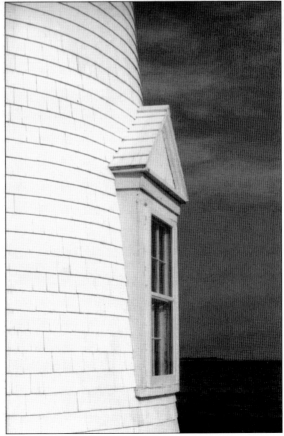

Although the structure at Prospect Harbor Lighthouse has been restored, the interior of the tower, as well as the stairs leading up to the lantern room, have deteriorated with age. (Courtesy Lighthouse Digest.)

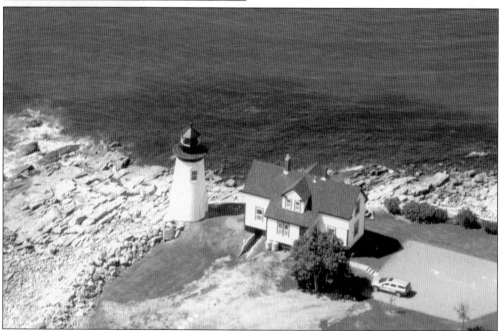

Old lighthouse homes have their share of creaks and groans, something that seems to be more prevalent during stormy or fog-shrouded nights. Some people who have spent the night at Prospect Harbor Lighthouse have reported strange and ghostly happenings occurring in the house. (Courtesy Ron Foster.)

Nine

PRIVATELY OWNED LIGHTHOUSES

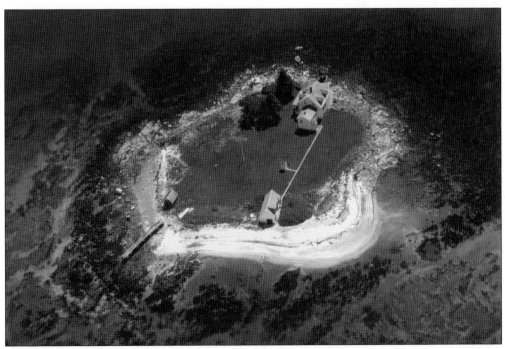

Blue Hill Bay Lighthouse was established in 1857 on Green Island on the west side of Blue Hill Bay. The light was built primarily to guide ships laden with lumber, granite, ice that once traversed these waters. This was followed in later years by steamships loaded with tourists. With an average 10-foot tide, the island changes in appearance twice a day. (Courtesy Ron Foster.)

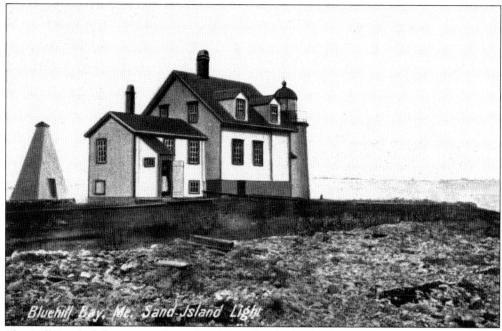

Blue Hill Bay Lighthouse was also referred to as Sand Island. The pyramid-shaped structure was the fog bell tower that was operated by weights, similar to a grandfather clock. Roscoe and Mary Chandler maintained the Blue Hill Bay Lighthouse in the 1920s. During most of the school year, Mary and the children lived on the mainland, leaving Roscoe to tend to the lighthouse on his own. During the winter months, Roscoe kept a cow in the barn, at the lighthouse, so he would always be assured of fresh milk. (Courtesy Lighthouse Digest.)

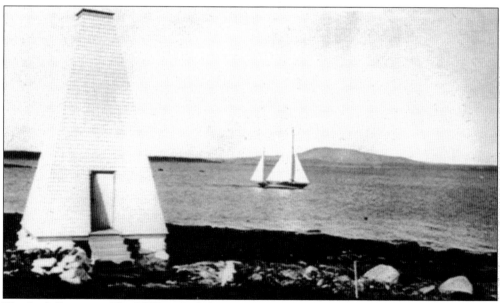

The fog bell tower at Blue Hill Bay Lighthouse is seen as it appeared in 1931, shortly before it was discontinued and demolished. (Courtesy Joseph G. Kelley.)

Many of Maine's lighthouses once had miniature brass lighthouses that served as railing caps on the outside walkway. During and after automation, most of these were removed or stolen from the lighthouses. (Courtesy Lighthouse Digest.)

As well as providing a light for the mariner at sea, the USLHS also established airway beacons to light up the sky to help guide early mail pilots across the country. The 1928 U.S. Airmail postage stamp depicts one such airways tower. By 1932, almost one third of the employees of the USLHS were employed on aircraft navigation systems. Eventually all duties pertaining to air flight were transferred to other government agencies that eventually evolved into the FAA.

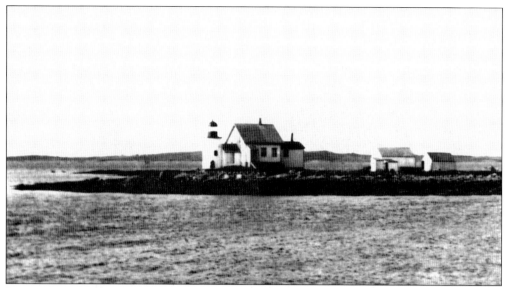

During Roscoe Chandler's time at Blue Hill Bay Lighthouse, the government allotted them 500 gallons of kerosene for the lighthouse lens and the lamps in the keeper's house. They were also given 10 tons of coal, a barrel of corned beef, two barrels of flour, one barrel of sugar, and crocks of salt eggs. They were also provided an 18-foot dory with three sets of oars. They would have to provide for themselves any other staples or supplies that might be needed or required. Although telephones were installed at most of Maine's lighthouse, the keeper here was never afforded that luxury. (Courtesy U.S. Coast Guard.)

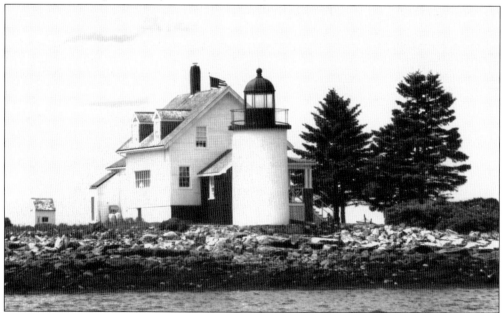

Although the island is quite small, the families that lived at Blue Hill Bay Lighthouse had enough room for their children to play, a garden for vegetables, and plenty of room for farm animals. In 1933, the government decided that Blue Hill Bay Lighthouse was no longer needed, and it was discontinued. Eventually the government sold the lighthouse, and it has remained in private ownership ever since. (Courtesy Ron Foster.)

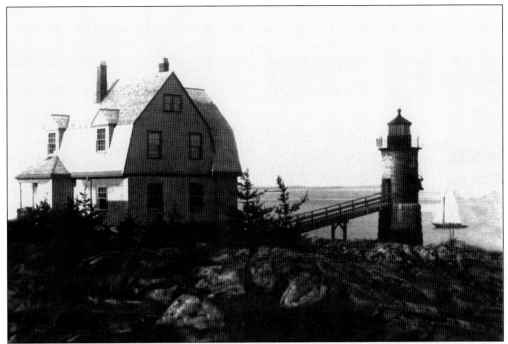

Established in 1907 by the USLHS, the Isle au Haut Lighthouse is located on Robinson Point on the Isle au Haut, which is an island overlooking the Isle Au Haut Thorofare. Because of its location, the lighthouse is often referred to as the Robinson Point Lighthouse. (Courtesy Lighthouse Digest.)

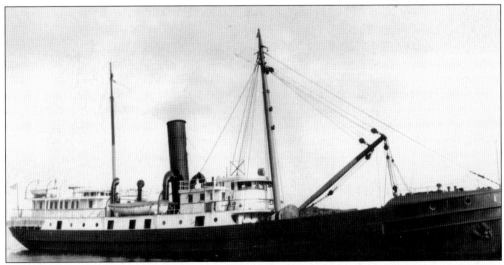

The lighthouse tender *Azalea* was one of the various vessels of the USLHS that delivered supplies, mail, and the rotating library to the families that lived at the lighthouses. Sometimes a work crew or the district machinist would be on board to do work at the lighthouse. From time to time, the lighthouse inspector would also be on board for a surprise inspection visit to the lighthouse. A large brass lighthouse was always on the bow of each lighthouse tender. (Courtesy Lighthouse Digest.)

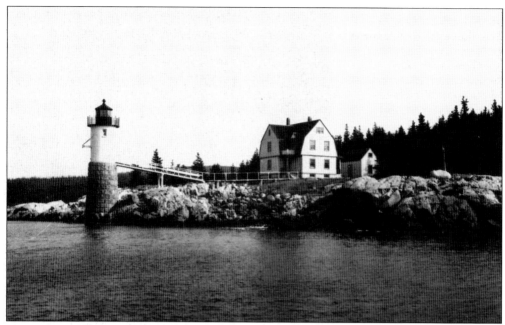

The Isle au Haut Lighthouse was among the early lighthouses along the Maine coast to be automated and have its keepers removed. In the 1930s, the keeper's house was sold and has remained in private ownership. Jeff and Judi Burke purchased the house in 1986 and converted it to a successful bed-and-breakfast called the Keeper's House. Burke wrote a book called *An Island Lighthouse Inn: A Chronicle*, which described his and his wife's first years on the island. They listed the property for sale in 2007. (Courtesy U.S. Coast Guard.)

The restored interior of the lighthouse keeper's house at Isle au Haut Lighthouse looks better today than it did when the lighthouse families lived there. (Courtesy Library of Congress.)

Rented out for overnight stays, the restored oil house at the Isle au Haut Lighthouse is, without doubt, the best-looking oil house at any lighthouse on the Maine coast. (Courtesy Library of Congress.)

The barn at Isle au Haut Lighthouse was used for farm animals and equipment storage. It was restored for overnight stays, which is quite different than its original intended use. (Courtesy Library of Congress.)

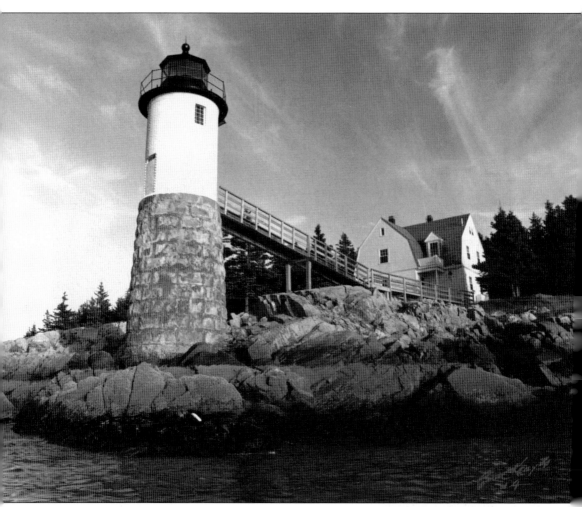

Although the keeper's house at Isle au Haut Lighthouse is privately owned, in 1998, under the Maine Lights Program, ownership of the lighthouse tower was transferred to the Town of Isle au Haut. The tower has since been fully restored. Visitation to Isle au Haut is limited to the number of passengers that the mail boat can carry. The valuable Frensel lens that was once in the tower is now on display at the Maine Lighthouse Museum in Rockland. (Courtesy Lighthouse Digest.)

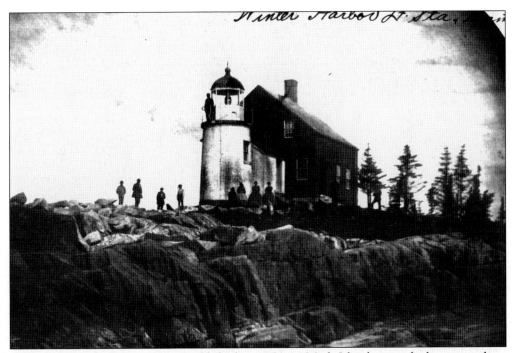

Winter Harbor Lighthouse was established in 1856 on Mark Island to mark the approach to Winter Harbor between the Schoodic Peninsula and Grindstone Neck. Although it was a single-family station, there were a number of visitors to the island when this photograph was taken. (Courtesy National Archives.)

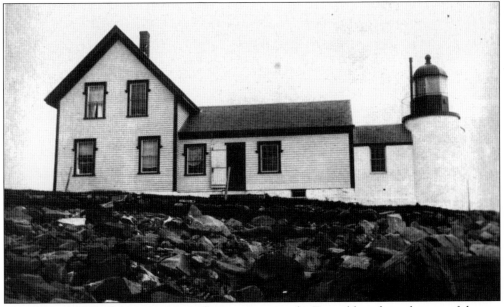

The curtains in the lantern room are drawn to protect the Fresnel lens from the rays of the sun at Winter Harbor Lighthouse. As dusk would approach, the keeper would open the drapes and light the wick of the lamp so the lantern could cast its warning beam to the mariners at sea. (Courtesy Lighthouse Digest.)

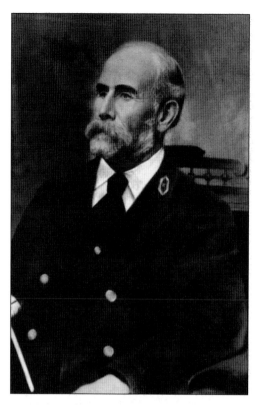

The distinguished-looking Benjamin Maddox, and his wife, Olivette, lived at Winter Harbor Lighthouse from 1888 to 1896. Before being appointed the head keeper at Winter Harbor Lighthouse, Maddox served as the second assistant keeper at Mount Desert Rock Lighthouse from 1883 to 1888. Born in 1831, Maddox was a Civil War veteran and served in Company C of the First Maine Heavy Artillery. (Courtesy Merridee Marcus.)

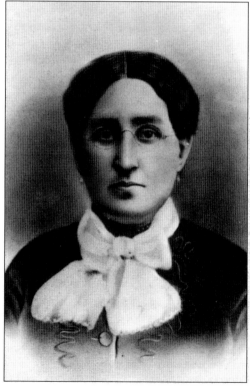

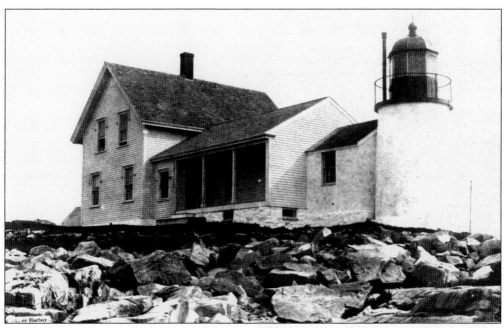

At some point, the lighthouse keeper's house at Winter Harbor Lighthouse was made slightly smaller to accommodate an open porch so the keeper and his family could relax and enjoy the view after a hard day of work. (Courtesy National Archives.)

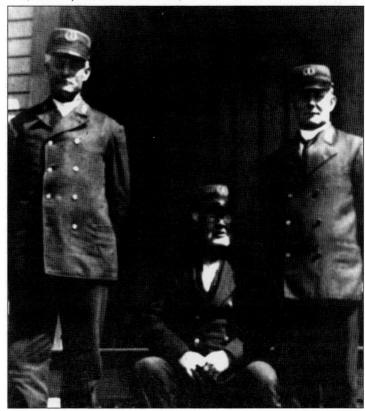

Adelbert Leighton, shown sitting, arrived as the lighthouse keeper at Winter Harbor Lighthouse in 1896. He was previously stationed at Petit Manan Lighthouse. Pictured with Leighton, to the left, is keeper Lewis Sawyer with his son Heber on the right. Both of the Sawyers served as lighthouse keepers at different times at Baker Island Lighthouse and Bear Island Lighthouse. Leighton was succeeded at Winter Harbor Lighthouse by Lester Leighton, who served as the lighthouse keeper until the lighthouse was discontinued in 1933. (Courtesy Alberta Willey.)

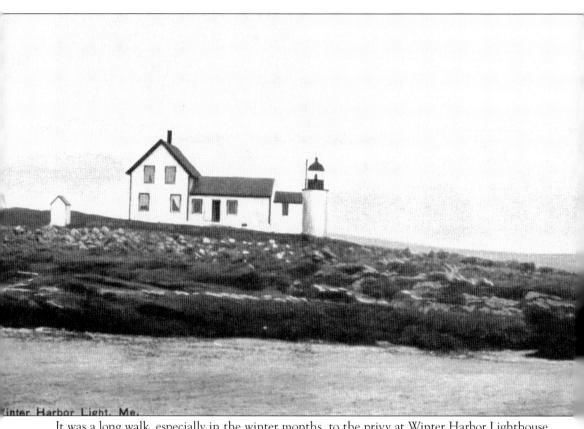

inter Harbor Light, Me.

It was a long walk, especially in the winter months, to the privy at Winter Harbor Lighthouse. (Courtesy Lighthouse Digest.)

In 1939, Bernice and Reginald Robinson purchased Winter Harbor Lighthouse and owned it for a number of years. Bernice authored a number of books, including two books about her life on the island, *Winter Harbor* and *Our Island Lighthouse*. Both books make for pleasurable reading, especially in today's hectic age. (Courtesy Lighthouse Digest.)

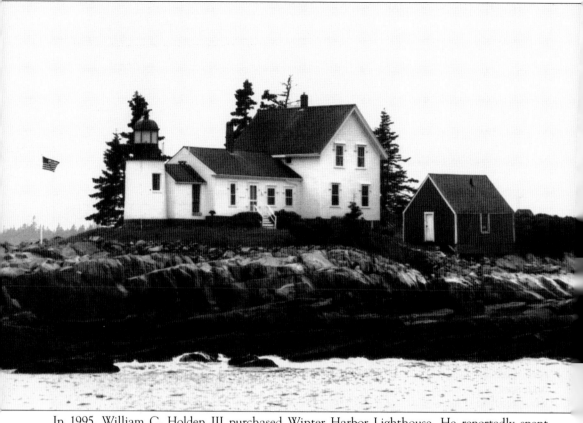

In 1995, William C. Holden III purchased Winter Harbor Lighthouse. He reportedly spent approximately $650,000 to buy and restore the lighthouse, which he later sold. While living there, he said in a story in *Lighthouse Digest*, "I don't feel like I own it. I feel like a caretaker, like I am entrusted with it. It's a very special place." During the 10 years he lived there, he took more than 1,000 photographs and produced over 150 paintings, sketches, and diagrams from which he plans to make a book about his life at the lighthouse. (Courtesy Ron Foster.)

Ten

LIGHTHOUSE NOTABLES

W. H. "Grandpa" Law posed for this photograph on his retirement after spending a lifetime on the high seas as a minister who preached the gospel to lighthouse keepers and the crews on lighthouse tenders. Known as the "Sky Pilot to the Light Housemen," the newspaper accounts, reporting on his retirement, said he would be greatly missed by every lighthouse keeper in the United States. He corresponded with many lighthouse keepers and wrote numerous stories that were widely published in magazines and newspapers throughout the United States. In those days, since there was no financial aid or pension for lighthouse keepers, Law would personally give financial assistance to many of the keepers. (Courtesy Lighthouse Digest.)

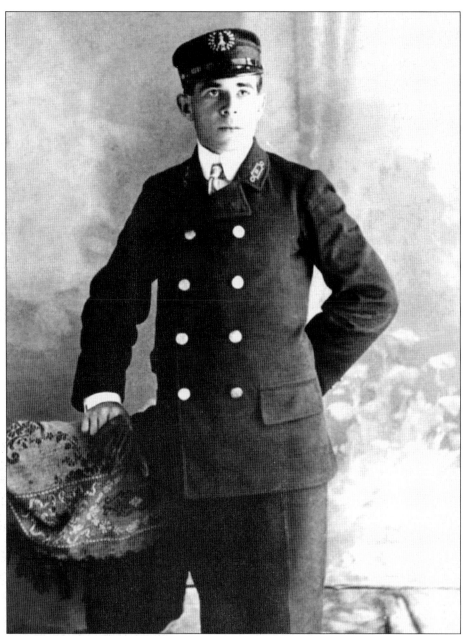

Born in 1883 to the son of a lighthouse keeper, Frederic W. Morong Jr. joined the USLHS in 1922. He started his career as a mechanic and worked his way up through the ranks to the highly respected position of district machinist. As the district machinist, he often worked on the lens and foghorn apparatuses at many of Maine's lighthouses. Morong often stayed overnight at the lighthouses and became good friends with the lighthouse families. After continually hearing the lighthouse keepers complain about keeping all the brass parts in shining order, especially after he had made repairs, he composed the poem *It's Brasswork*, which became known as *The Lighthouse Keeper's Lament*. Its words are now on display at Little River Lighthouse in Cutler, where the poem was penned at the kitchen table. Morong was eventually promoted to lighthouse inspector, a position he held until his retirement. (Courtesy Charles Morong.)

Seen here in 2002 are Connie Small, known as "Maine's First Lady of Light," at the age of 101, with author Timothy E. Harrison. Harrison is holding a copy of Connie's book, *The Lighthouse Keeper's Wife*, which she wrote when she was 83 years old. Small is holding a copy of *The Golden Age of American Lighthouses*, which was coauthored by Harrison. By the time Small was 100 years old, she had given over 600 lectures on family lighthouse life, something she continued do until a few weeks before her death at the age of 103. (Courtesy Lighthouse Digest.)

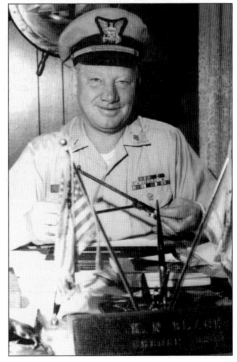

Chief Warrant Officer Kenneth Black of the U.S. Coast Guard, known as "Mr. Lighthouse," was the founder of the Maine Lighthouse Museum in Rockland, which is home to the largest collection of lighthouse artifacts in the nation. After his retirement from the U.S. Coast Guard, he spent the rest of his life searching for artifacts for the museum that he founded. He was also the first person to start a national newsletter on lighthouses. Black, who was a mentor and close personal friend of the author, passed away in 2007. (Courtesy Lighthouse Digest.)

ACROSS AMERICA, PEOPLE ARE DISCOVERING SOMETHING WONDERFUL. *THEIR HERITAGE.*

Arcadia Publishing is the leading local history publisher in the United States. With more than 3,000 titles in print and hundreds of new titles released every year, Arcadia has extensive specialized experience chronicling the history of communities and celebrating America's hidden stories, bringing to life the people, places, and events from the past. To discover the history of other communities across the nation, please visit:

www.arcadiapublishing.com

Customized search tools allow you to find regional history books about the town where you grew up, the cities where your friends and family live, the town where your parents met, or even that retirement spot you've been dreaming about.